IMAGES
of America

CHICAGO'S
WLS RADIO

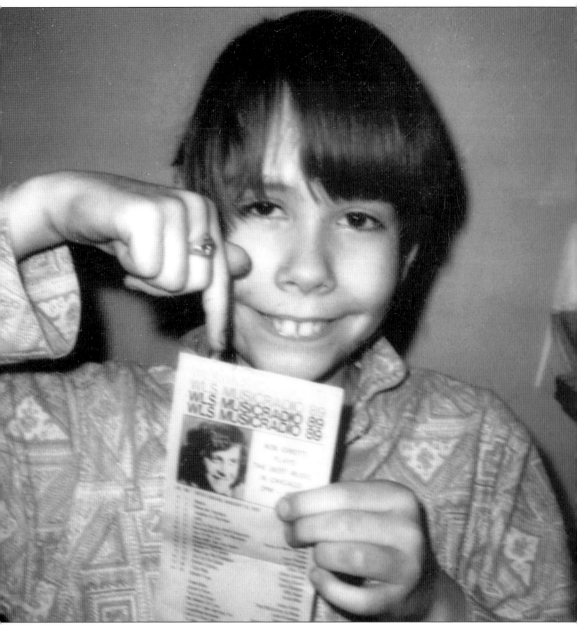

Throughout the history of WLS, the station captured the imagination and touched the lives of many people young and old, from all walks of life. Author Scott Childers, at age 10, is pictured pointing to Bob Sirott on a Musicradio survey dated January 25, 1975. He later went on to work with Sirott at NBC-5 and Fox 32 television in the 1990s.

On the cover: Bob Sirott and Larry Lujack "share a laugh" looking through the *WLS Personality Album.* This photograph is an alternate take of the picture that was used on the cover of the December 1976 edition *Triad Magazine,* which was published by Chicago station WXFM-FM. The magazine featured an article on the Chicago radio scene. *Triad* was a progressive, free-form "underground" style radio program that aired between 1969 and 1977. (Courtesy of John Gehron.)

IMAGES
of America

CHICAGO'S WLS RADIO

Scott Childers

ARCADIA
PUBLISHING

Published by Arcadia Publishing
Charleston SC, Chicago IL, Portsmouth NH, San Francisco CA

Printed in the United States of America

Library of Congress Catalog Card Number: 2008929808

For all general information contact Arcadia Publishing at:
Telephone 843-853-2070
Fax 843-853-0044
E-mail sales@arcadiapublishing.com
For customer service and orders:
Toll-Free 1-888-313-2665

Visit us on the Internet at www.arcadiapublishing.com

This book is dedicated to all the wonderful people who have strived throughout the years to make WLS what it is, a legendary radio station. It is also dedicated to my mother, Barbara, who allowed me to nurture my dreams, and to my wife, Nina, who made it possible that I followed through with them.

CONTENTS

ACKNOWLEDGMENTS

I am grateful to the people who were willing to share their personal photographs, materials, and stories as well as their time and consideration. A book covering this wide of an era makes for the inclusion of plenty of material. Many thanks to James Arntz, lifelong friend Chris Bejcek, Wendy Bernstein, Chris Cline, Frank Crescenzi, Jean Davis, Ken Deutsch, Robert Feder of the *Chicago Sun-Times*, Colleen Gerstein, Les Grobstein, Karen Hand, Catherine Johns, Timothy Johnson, Tom Johnson, Rick Kaempfer, Ric Lippincott, Arlene May of the Sears Roebuck Archives, Jim Moran, WLS alumni coordinator Michaela Nelson, John Oharenko, John Paulson, *Hayloft Gang* producer Steve Parry, Jay Philpott, *Radio Ink Magazine* publisher Eric Rhoads, John Rook, Chuck Schaden, longtime WLS engineer and frequent *Animal Stories* correspondent Dale Shimp, Bill Sixty, Ron Smith, Clark Weber, Linda Waldman, Harvey Wittenberg, Jonathan Wolfert, and the current staff at WLS Radio.

Thanks to current WLS program director Kipper McGee, the invaluable help of fellow historian Michael Garay, and Musicradio era program director and general manager John Gehron for all their efforts and assistance.

Many books and reference material were indispensable during this process, including *Prairie Farmer and WLS* by James F. Evans, *Thinkin' Out Loud* by Art Roberts, *Superjock* by Larry Lujack and Dan Jedlicka, *Personality Radio Chicago* by Stew Salowitz, as well as countless newspaper and magazine articles, Web sites, pamphlets, newsletters, personal interviews, and various scraps of paper. Several images appear courtesy of the Chicago Sun-Times. Where credited, they are copyright 1966–1987 by Chicago Sun-Times, Inc. Reprinted with permission.

A hearty thank-you to Jeff Davis, Tommy Edwards, and Tom Graye, all of whom provided the inspiration for me to get into the radio business. Special thanks to my wife, Nina, for her support, organizational skills, and for keeping me on track when I would start to drift during this project.

I would also like to tip my cap to Arcadia Publishing editor Jeff Ruetsche and publisher John Pearson for their assistance, guidance, and being able to see my vision; as well as my current employer WSSR-FM Star 96.7 and NextMedia for their patience and consideration during the compilation of this book.

Visit Scott's WLS history Web site at www.WLSHistory.com. Visit Scott on the Web at www.scottchilders.com.

INTRODUCTION

Builders of the Egyptian pyramids came up with an entirely different way of thinking about spirituality, building methods, and cultural hierarchy, all the while seeking relativity to the rest of the universe. We often think of those pyramids as part of one era, closely related in time between a finite number of dynasties. Few of us pause to think of the generations it took to build them. We do not think of how many centuries the tribes of Egypt were under royal rule. We do not know who was the first man who ascended above a poor and humble people to become Egypt's first king. The pharaohs of ancient Egypt were at the peak of power for 3,000 years. It took about 1,000 years to built the pyramids; pyramids of heights, architecture, knowledge, and skills that were vastly different and yet share similar ideologies in structure. Even if there were a written record, there would be no way to verify with certainty what may or may not be the actual history. We do not know how many kings there were or how many dynasties. So, in a very odd manner of being out of touch with the past, we lump them all together.

The Egyptian kings ruled for 3,000 years, but radio broadcasting for general consumption has only been in existence for scarcely a century.

In more ways that you may realize, radio broadcasting has an odd parallel with ancient Egypt. I recently went to a luncheon held by the Pacific Pioneer Broadcasters in Los Angeles, California. Looking around the banquet room, nearly all the people were a generation or two older than I. One of the older gentlemen was well known to me and, though anonymous to most Americans over 40, was certainly known by his signature voice. When I was a little boy in the 1950s, Art Gilmore was the movie trailer voice for some of the biggest blockbuster films of the time. He was the authoritative narrator for Broderick Crawford's *Highway Patrol*. He was the voice you heard, uplifting the mood for Garner Ted Armstrong's Ambassador College television program, *The World Tomorrow*. His voice graced so many radio and television shows it would make anyone envious to have even 10 percent of his success. He was the announcer for *Amos and Andy*, appeared on the *Mary Tyler Moore Show*, *The Waltons*, and, many years earlier, provided the voice for Franklin Delano Roosevelt in the Warner Brothers classic musical *Yankee Doodle Dandy*. As an actor, he was on Jack Webb's *Dragnet*.

Art Gilmore had formed the Pacific Pioneer Broadcasters many years earlier, and he was at the luncheon. Despite the advanced age of 95, he looked pretty good. I had been fortunate enough to work with Art many years before and was glad to see an old friend I never knew as a kid but got to know as an adult. The thought occurred to me that Art had seen so many things in the various eras of radio broadcasting since his arrival in 1936. In reality, future generations will lump the most progressive aspects of what, in our time, we call modern, with the percussive bandwidth of the earliest AM radio stations.

It is very important that good records, materials, recollections of our experiences, and the memories of the people who came before are all preserved. There are definite differences between the beginning days of commercial broadcasting, the so-called "Golden" era of radio, and the radio that blanketed the planet at the close of the 20th century and the beginning of the third millennia. Without a good, solid record showing comparative examples of our heritage we are destined to be all lumped together, mixed in the same bowl of history soup, much like the 3,000 years of distant, long-passed civilization.

WLS AM, a radio station with humble beginnings, was in some ways an experiment. Executives at Sears, Roebuck and Company were interested in having a mass means of reaching a rural audience, an audience that relied on the Sears catalog to learn about and purchase products through mail order. There were no commercials on the radio, but there was a lot of good will, and Sears wanted to be at the forefront. The experiment became one of the true American success stories, not of just one person or entity, but a cornucopia of success stories that still yields results today.

WLS AM had three distinct eras that can be separated into the *Barn Dance* years, the Musicradio years, and the News-Talk years.

Even though each change for WLS was a radical one, some people from each of those eras continued to be a part of the evolving story of the "50,000 Watt Blowtorch out of the Midwest."

Sears only owned WLS (an acronym for World's Largest Store) for a few years and then sold to Burridge D. Butler's farm publication, the *Prairie Farmer*. Butler's philosophy was compatible with that of Sears, and in the time he was at the helm of WLS AM, he brought the radio station onto a national stage. WLS personalities such as Gene Autry, George Gobel, Rex Allen, Andy Williams, and many others rose through the ranks to become actors and performers in movies and, later, television. It was a truly remarkable breeding ground for talent that developed a huge following. WLS's signature weekend program, *The National Barn Dance*, was the precursor and model for the famous WSM (Nashville) program *The Grand Ole Opry*. The WLS *Barn Dance* was eventually carried live over the NBC Blue Network. WLS often had huge crowds at its appearances. In 1937, a WLS feature reporter named Herb Morrison took a recorder (a 200-pound disc recorder) and an engineer to Lakehurst, New Jersey, and was at the scene of one of the seminal news events of pre–World War II America: the *Hindenburg* disaster. By the 1950s, WLS's country-fried image became more "countrypolitan." Live music sets, the mainstay of commercial radio, were becoming a thing of the past, yielding to prerecorded music.

In May 1960, after being sold to ABC-Paramount, WLS began its second era as it shed the garments of country in favor of pop music, a format that was later referred to as Top 40. Gone were the strains of fiddlers and homespun humor, only to be replaced by the manic laughter of the Big Bopper. Quick patter was given by the deejay (an abbreviated term for the radio personalities called disc jockeys because music was played on a vinyl disc, or record), usually trying to say something funny or memorable for the listener. The disc jockeys, as did their more performance-oriented predecessors, made many public appearances, sometimes with major music stars in accompaniment.

There were also sub-eras to the Musicradio era. The music of the 1950s is quite different than the music of the 1960s, and each subsequent decade had a unique identity. I was fortunate to be involved with WLS, as I still am, over a period of nearly four decades. During my time as a radio personality at WLS, there was a national rating taken and, because WLS was a 50,000-watt station broadcasting in all directions, we had eight million listeners in 38 states. Over that period a who's who of personalities stopped by our studios to promote their latest efforts.

WLS had lots of clout, and if we played a record it would likely become a hit. I had "discovered" a relatively unknown local Chicago band that had all but broken up. With some persistent lobbying I got permission to play their music on my radio show. The reaction was highly positive, and a group called Styx ended up with their first hit, a song I first heard on a local jukebox, called "Lady." WLS was also influential in helping groups like Heart get exposure to a huge audience.

There were many groups and artists that knew the power of the station's reach was not only desirable but also mandatory for their music to become successful.

We also had a number of memorable personalities in each of those decades: most notably, Art Roberts, Dex Card, and Dick Biondi in the 1960s; and Fred Winston, Larry Lujack, Bob Sirott, and John Landecker in the 1970s. Radio personalities would listen to WLS nightly in far-flung locations and would often imitate us or "borrow" our material. It was strange to be driving out of state while I had just gone on vacation only to hear something I had said the night before on a little station in the middle of nowhere. WLS personalities were, through each generation, role models for developing talent. It is a legacy that exists to this day.

In the 1980s, WLS began one of its inevitable changes, changes that would alter the station forever.

The third era of WLS came as the penetration of FM radio pulled music listeners away from AM for the fidelity and stereo audio of an FM signal. Out of pure logic, radio became the bastion of talk radio. The human voice can easily be tolerated at half the frequency response credited to FM, which means that the fidelity for voices over the air is well suited for AM. Many radio stations that once played music on AM radio had long since moved to talk or sports. WLS, attesting to the popularity of its image, was one of the last holdouts. With the reprieve WLS had, there was an attempt at evolving the station away from music and gently easing our listeners along to a new format: News-Talk. WLS was trying to have it both ways, and based on the result, it apparently worked. WLS during this period, as it always did, gave rise to major new talents: the matrimonial morning duo, Don Wade and Roma; afternoon stalwart Roe Conn; and WLS became the radio home in Chicago for the man often credited with "saving" talk radio, Rush Limbaugh.

With the advent of HD radio, active content for radio broadcasters on the Internet, and possibilities for other technological means of delivering broadcasts, it is impossible to know what radio will be like in 100 years. One thing is certain, when seen through the obscuring sandstorms of time, anyone active during WLS's first 100 years will be considered a radio pioneer.

Jeff Davis
WLS Air Personality and Station Voice

Hayes-Loeb and Company, a Chicago advertising firm, contacted Sears-Roebuck and Company advertising manager E. H. Powell with the idea of forming an agricultural foundation that would service the farmer as well as promote goodwill. Sears was already a trusted merchant to the farmer, so the agricultural foundation was used as a way to help farmers with their problems and questions. Better yet, it was done free of charge. This 1926 advertisement makes clear the mission of the Sears-Roebuck Agricultural Foundation, which cemented the bond between farmer and merchant. (Courtesy of the Sears Holdings Archives.)

One

THE SEARS-ROEBUCK STATION

The 1920s brought radio out of the basements and laboratories and into the public eye. Many credit KDKA in Pittsburgh as being the first commercial radio station in America. In Chicago, many stations signed on the air, including KYW, WGU (later known as WMAQ), WDAP and WAAF (later merged as WGN), and WJAZ. When Sears decided it would air programming to advance the Sears-Roebuck Agricultural Foundation, it did so by buying airtime on other radio stations. In 1923, Sears applied for a radio license and made a commitment that its new broadcast station would serve the rural community.

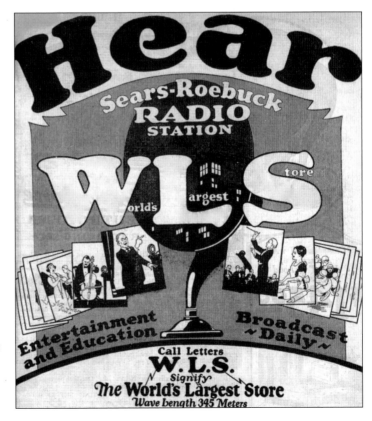

In forming the Sears-Roebuck Agricultural Foundation in 1923, Sears president Julius Rosenwald (right) felt that agricultural research was critical to the 20th-century farmer. He also believed that economics and marketing would be most beneficial for the best returns and radio was key in helping get the message out. When the Sears station was finally formed, Rosenwald hired Edgar Bill from the Illinois Agricultural Association to become director of WLS. (Courtesy of John Oharenko and the Homan Arthington Foundation.)

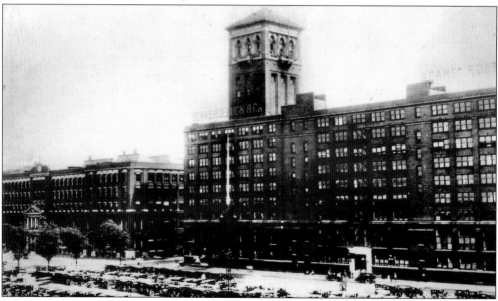

The Sears-Roebuck headquarters was located on Chicago's west side. WLS Radio was on the 11th floor of the 14-story building. It housed offices, a studio, and transmitter equipment and was located next to the offices of the Sears-Roebuck Agricultural Foundation. The main studio was located on the mezzanine level of the Sherman House Hotel in downtown Chicago and sent its programming back to Sears Tower over special telephone lines. (Courtesy of John Oharenko and the Homan Arthington Foundation.)

By March 1924, Sears began testing its new facilities. This advertisement appeared in many local and national publications, heralding the upcoming debut of the new station that will provide "entertainment and education to the world" from "The World's Biggest Store." During the testing period, many call letters were tried out, as illustrated in this advertisement for WJR. Call letters WBBX and WES (for World's Economy Store) were also used during the testing period. According to George Biggar, Sears farm and market director, "As I remember the call letters 'WLS' were not definitely selected until that afternoon [of the inaugural broadcast of April 12]. Much consideration had been given to the other call letters."

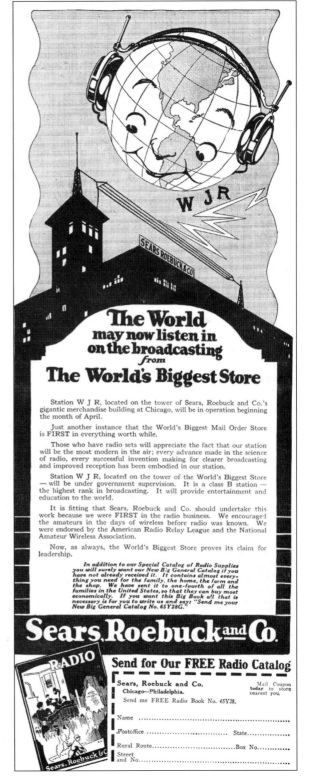

The World
may now listen in
on the broadcasting
from
The World's Biggest Store

Station W J R, located on the tower of Sears, Roebuck and Co.'s gigantic merchandise building at Chicago, will be in operation beginning the month of April.

Just another instance that the World's Biggest Mail Order Store is FIRST in everything worth while.

Those who have radio sets will appreciate the fact that our station will be the most modern in the air; every advance made in the science of radio, every successful invention making for clearer broadcasting and improved reception has been embodied in our station.

Station W J R, located on the tower of the World's Biggest Store — will be under government supervision. It is a class B station — the highest rank in broadcasting. It will provide entertainment and education to the world.

It is fitting that Sears, Roebuck and Co. should undertake this work because we were FIRST in the radio business. We encouraged the amateurs in the days of wireless before radio was known. We were endorsed by the American Radio Relay League and the National Amateur Wireless Association.

Now, as always, the World's Biggest Store proves its claim for leadership.

In addition to our Special Catalog of Radio Supplies you will surely want our New Big General Catalog if you have not already received it. It contains almost everything you need for the family, the home, the farm and the shop. We have sent it to one-fourth of all the families in the United States, so that they can buy most economically. If you want this Big Book all that is necessary is for you to write us and say: "Send me your New Big General Catalog No. 65Y28G.

Sears, Roebuck and Co.

Send for Our FREE Radio Catalog

Sears, Roebuck and Co.
Chicago—Philadelphia.
Send me FREE Radio Book No. 65Y28.

Mail Coupon today to store nearest you.

Name ..

Postoffice State..................

Rural Route.............................Box No..............

Street
and No..

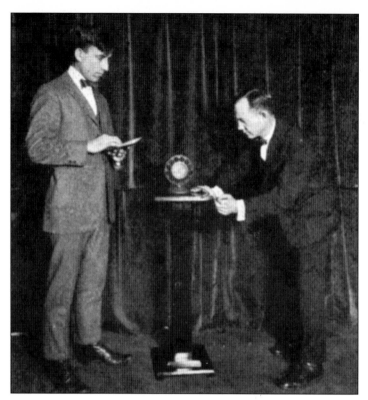

Samuel R. Guard (left) and Edgar Bill are preparing a microphone, hours before the initial broadcast on April 11, 1924, from a small studio in the Sherman House Hotel. They were known as WLS's first "brain trust." Guard was secretary of the Sears-Roebuck Agricultural Foundation. It was Bill that brought the idea of assembling a country dance show. That idea became the WLS *Barn Dance*, which first aired on Saturday, April 19, 1924.

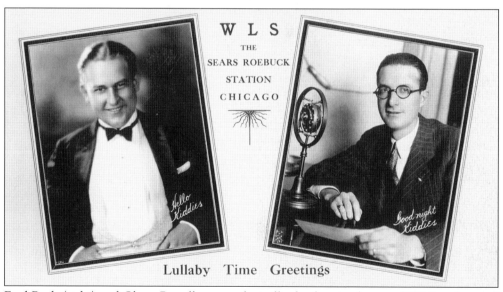

Ford Rush (right) and Glenn Rowell were technically the first employees of WLS and started their radio careers with the inaugural broadcast. Ford was the first studio announcer and went on to become studio director, while Rowell was in charge of the station's music department. This postcard was sent to children who listened to their *Lullaby Time* program from 7:00 to 7:20 every evening. The opening was "Come all you kiddies—it's Lullaby Time. Lullaby Time—sleepy head time. Put on your nighties and climb into bed."

Actress Ethel Barrymore was one of the many celebrities and dignitaries who were invited to WLS's inaugural broadcast. Shortly after 6:00 p.m., she was introduced to begin the broadcast. Barrymore took the stage and immediately froze with microphone fright. After a few tense seconds, she blurted out to "turn that damned thing off!" Other accounts say that Barrymore fainted after seeing the newfangled microphone. In any case, the stunned studio crew quickly ushered her off the stage.

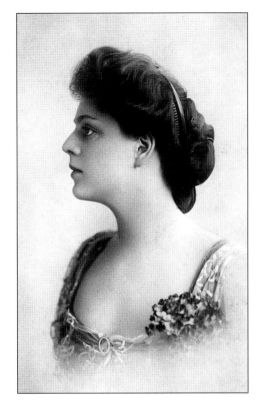

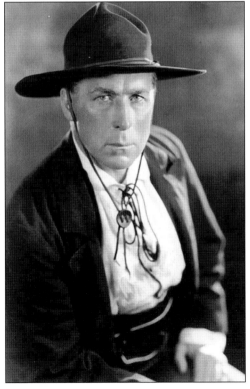

After Ethel Barrymore's less than polite introduction, the microphone was turned over to silent cowboy movie star William S. Hart. Hart, according to George Biggar, "shut his eyes, clenched his fists and with perspiration running down his face, recited *Invictus*," a short poem by the British poet William Ernest Henley. WLS's Glenn Rowell later wrote "I wondered what Bill Hart could do on the radio without people seeing that long horse-face of his!"

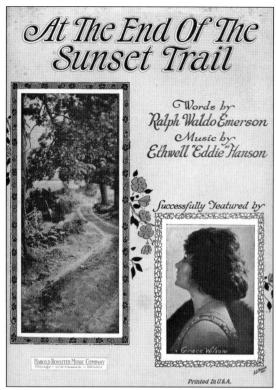

Grace Wilson was known as "the girl with a million friends." Her career had started in Vaudeville, but she was on the ground floor of technology when she sang "At the End of the Sunset Trail" during the inaugural WLS broadcast. She was featured as a singer on the first *Barn Dance* program. Wilson lasted the longest during the station's agricultural period, 33 years, and sang on the last *National Barn Dance* program in 1960.

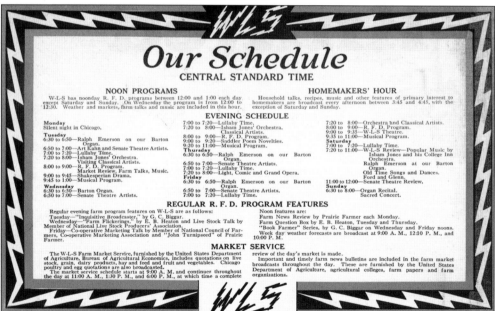

Here is a typical schedule of programs that aired in 1925. WLS had restricted hours due to sharing the 870 kHz frequency with radio station WCBD. In 1928, WCBD moved to 1080. WLS then shared the frequency with WENR until 1954, when both stations were consolidated into a single operation. Note that Monday nights were called "Silent Night in Chicago." In the early years, many stations observed silent nights so that listeners could pick up distant stations.

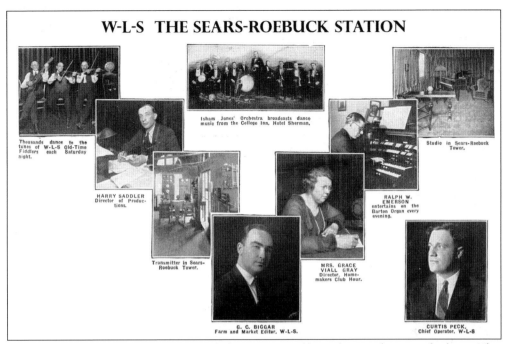

W-L-S THE SEARS-ROEBUCK STATION

Thousands dance to the tunes of W-L-S Old-Time Fiddlers each Saturday night.

Isham Jones' Orchestra broadcasts dance music from the College Inn, Hotel Sherman.

Studio in Sears-Roebuck Tower.

HARRY SADDLER Director of Productions.

Transmitter in Sears-Roebuck Tower.

RALPH W. EMERSON entertains on the Barton Organ every evening.

G. C. BIGGAR Farm and Market Editor, W-L-S.

MRS. GRACE VIALL GRAY Director, Homemakers Club Hour.

CURTIS PECK, Chief Operator, W-L-S

This early Sears press release illustrated the various staff members and station facilities. This image was released in 1924.

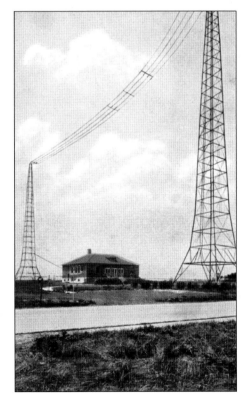

WLS's signal was transmitted from facilities located 30 miles south of Chicago in Crete, Illinois. Initially licensed to broadcast at 500 watts, it increased power to 5,000 watts in 1925. By 1931, the Crete location was vacated for WENR's 50,000-watt Downers Grove transmitter site, which WLS was able to use in exchange for airing a certain amount of NBC network programming. The wires stretched between the two towers are known as an end-fed dipole, which radiated the radio signal.

17

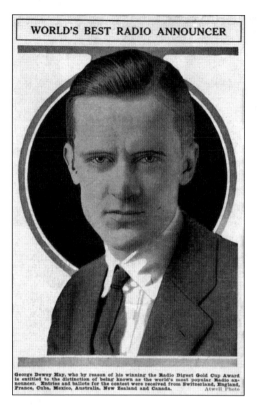

George Dewey Hay, who by reason of his winning the Radio Digest Gold Cup Award is entitled to the distinction of being known as the world's most popular Radio announcer. Entries and ballots for the contest were received from Switzerland, England, France, Cuba, Mexico, Australia, New Zealand and Canada. Atwell Photo

Although he was only 25 years old when he joined WLS in 1925, George Dewey Hay was known as "the Solemn Old Judge." Hay, who had become the first nationally prominent announcer at WLS, was awarded the Radio Digest Illustrated Gold Cup Award. He beat out 134 other announcers for the top honor and was awarded $5,000 and the 14-karat gold cup. This picture appeared in the September 20, 1924, edition of *Radio Digest Illustrated.*

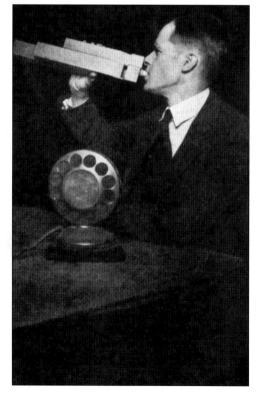

Hay is seen tooting his famous train whistle. One of the many programs he appeared on was a show called *WLS Unlimited.* He would often announce with a toot of his whistle and an animated "W-L-S Cha-CAWW-go, the Sears-Roebuck Station!" Hay also was the first announcer on the debut of the *National Barn Dance.* He left WLS in November 1925 for WSM Radio in Nashville. While there, Hay took the *Barn Dance* idea and started *The Grand Ole Opry.*

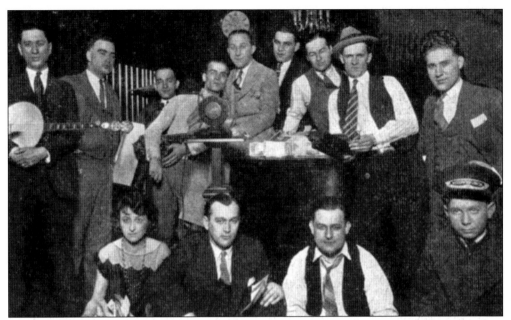

Pictured here is the WLS staff after three days and nights of continuous broadcasting to raise money for aid in southern Illinois and Indiana, which had been struck by a tornado. Beginning on March 18, 1925, the WLS Storm Relief Fund raised over $216,000 and hundreds of supplies in the nearly 36 hours they were on the air. From left to right, they are (first row) Martha Meier Whyland, Ford Rush, Glenn Rowell, and unidentified; (second row) unidentified, George Biggar, unidentified, Rex Maupin (in front of microphone), three unidentified, George Dewey Hay (with hat), and George Ferguson.

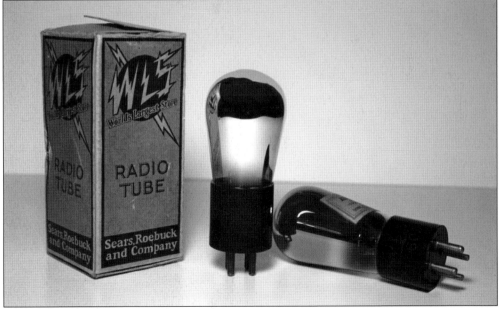

After the formation of the radio station, Sears made extensive use of the "WLS" and lightning logo brand. It was used to market products such as headphones, batteries, speakers, fishing reels, electronic parts, and radio vacuum tubes. (Photograph by Chris Bejcek.)

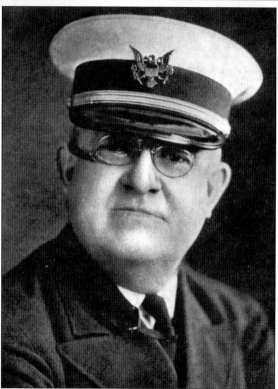

Tom Corwine (center) was the captain of the WLS *Showboat*, the "floating palace of wonder." It was a variety program that took listeners on a nautical journey every Friday evening, featuring skits, music, and readings. In addition to "Cap'n Tom," the *Showboat* also featured several first mates, including singing cowboy Bradley Kincaid, Harold Safford (who later become WLS's program director), organist Ralph Waldo Emerson (who provided the calliope music), and many singers and performers. Most of the sound effects were created by Corwine's own voice, rather than with recordings or instruments. Corwine came to WLS in 1925 and spent many years traveling with WLS live road shows as well as appearing on the *National Barn Dance*. Corwine was even employed by the U.S. government to entertain crews that were building the Panama Canal. In later years, he was the voice of *Rin-Tin-Tin* on NBC Radio.

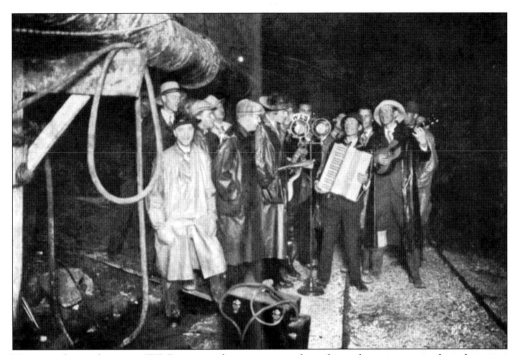

Even in the early years, WLS ventured into new and uncharted territories in broadcasting. This 1925 picture shows staff members and musicians doing a special broadcast in a tunnel that traveled under Lake Michigan.

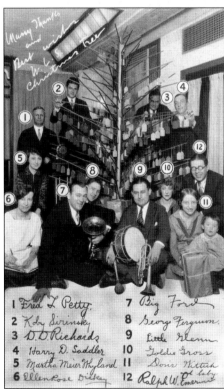

This 1926 postcard was sent to listeners who wrote WLS with questions, comments, or reception reports. The staff is pictured in front of a metal Christmas tree, with tags that were filled out by listeners and guests who had donated money or gifts to help underprivileged children. The back of the card reads, "It is our job to make life just a little more enjoyable and meaningful to all who turn their dials and hear W.L.S., Chicago."

1 Fred L. Petty.
2 Kol. Sirinsky
3 D. D Richards
4 Harry D. Saddler
5 Martha Meier Myland
6 Ellen Rose Dickey
7 Big Ford
8 George Ferguson.
9 Little Glenn
10 Goldie Gross
11 Doris Wittich
12 Ralph W. Emerson

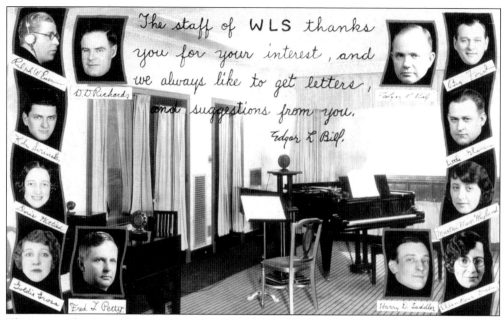

This postcard is from 1926. It features the WLS Sears Tower studios and the main announcers and performers. The handwritten note from director Edgar Bill was mass-produced on the cards. Clockwise from bottom left are Fred L. Petty, Goldie Gross, Doris Wittich, Koby Sirinsky, Ralph Waldo Emerson, D. D. Richards, Edgar Bill, Big Ford, Little Glenn, Martha Meier Whyland, Ellen Rose Dickey, and Harry D. Saddler.

Folk singer Bradley Kincaid joined WLS in 1926. His tenor voice and "houn' dawg" guitar paved the way for the southern folk singers that followed him in the years to come. Kincaid and WLS published a songbook entitled *Bradley Kincaid's Mountain Ballads*, which had sold over 10,000 copies by the time he left WLS in 1931. (Courtesy of Berea College, Southern Appalachian Archives, Bradley Kincaid Collection.)

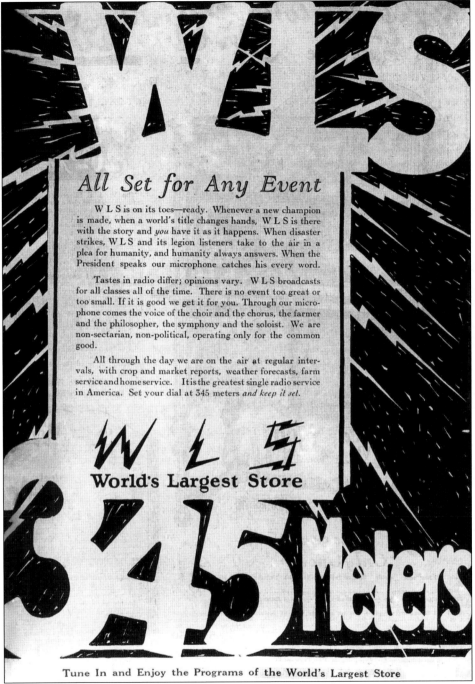

This advertisement from April 1927 stresses how WLS is there to cover the news and that its programming is designed for "all classes all of the time." It advises to "set your dial at 345 meters and keep it set." The term *meters* refers to the size of the wavelength at a given frequency—the unit of dial measurement in the early days of radio. A radio wavelength at 870 kHz (WLS's frequency at the time) would measure 345 meters long. (Courtesy of the Sears Holdings Archives.)

Luther Ossenbrink arrived at WLS in 1929 and assumed the persona of Arkie the Arkansas Woodchopper. He was known for having a somewhat raspy voice and was often good-naturedly heckled for singing off key. His singing would then give way to uproarious belly laughs. Some of the girls would also try to "fix Arkie" by removing his boots and tickling his feet. Arkie became one of the most popular performers on the *National Barn Dance*.

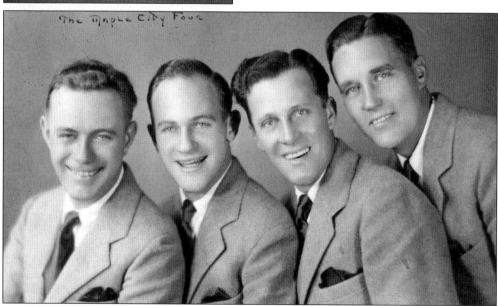

LaPorte, Indiana's Maple City Four debuted on November 19, 1926, and stayed with the station until the mid-1950s. The quartet mixed barbershop harmonies with wildly popular comedy and sketches. They also sang many commercials, including pitches for Ford, Purina, Kelloggs, and Caterpillar tractors. From left to right are Art Janes, Al Rice, Pat Patterson, and Fritz Meissner. Charles Kerner replaced Janes, who left the group due to illness in 1940. (Courtesy of Berea College, Southern Appalachian Archives.)

Two

THE PRAIRIE FARMER

By 1928, Sears was ready to get out of the broadcasting business, which meant the sale of WLS. It had plenty of potential suitors, but Sears felt that a sale to the Prairie Farmer magazine would be the best choice, given their longtime service to the farmer. On September 15, 1928, the sale to the Agricultural Broadcasting Company was consummated. This gave Prairie Farmer not only the radio facility but all the incredible talent WLS possessed, including the stars of the *National Barn Dance.*

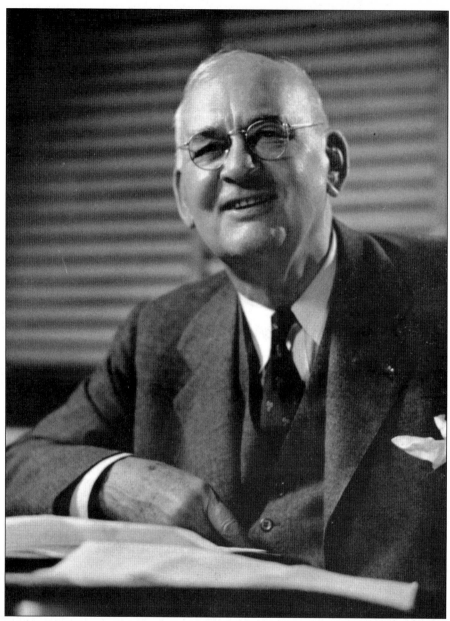

On October 1, 1928, an official on-air ceremony featuring Burridge Davanal Butler and E. H. Powell of Sears aired at 7:00 p.m. to herald the change in ownership. Butler was the publisher and owner of Prairie Farmer Publications from 1909 until his death in 1948. He was known to be a stern man but fair at the same time. He made sure that WLS and the *National Barn Dance* stayed clean and wholesome. Engineer and announcer Dale Shimp once remarked "you could be fired for playing the 'Beer Barrel Polka.' He insisted it be sung as 'The "MILK" Barrel Polka.' He had what may have seemed harsh rules for the period, but he had his ideals. If you didn't abide by his ideals you would find yourself looking hopelessly for another job." Rex Allen added "he wouldn't let any of us sing [the song] 'Divorce Me C.O.D.' The word divorce—you couldn't say that on the radio." At the time of his death, Butler owned 16 newspapers and two radio stations, WLS and KOY Radio in Phoenix.

Orvon Gene Autry was known around the world as the "Singing Cowboy." Autry began on WLS in 1930 as the "Oklahoma Yodeling Cowboy." In the early days, Autry was employed by Sears and the American Record Corporation, rather than by WLS. In 1935, the station would hire Autry for $35 a week. A few short years later, when he was America's number one cowboy, that fee would jump to $1,500 plus expenses!

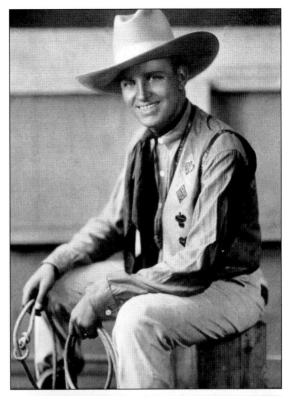

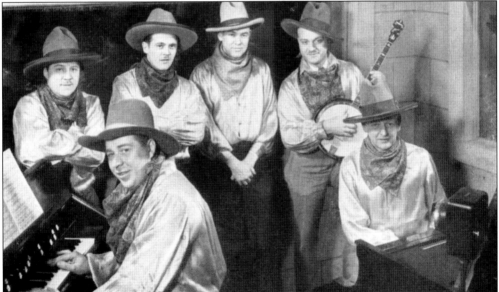

Chicago meatpacking giant Swift and Company purchased time on WLS for many years, beginning in the late 1920s. Its daily program *The Swift Roundup* was a mixture of business, home economics, and agriculture that featured farmers, politicians, and various charity and Scout organizations, as well as musicians that originated from studios located at the Swift plant. Pictured from left to right are the Swift rangers: Fred, Ozzie, Leonard, and Big Ben. Seated are Ralph Waldo Emerson and John Brown.

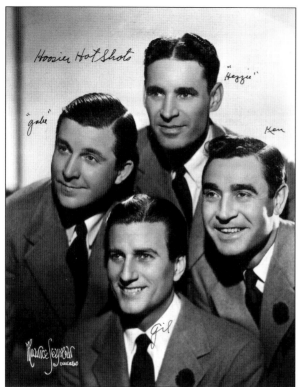

Seen are the Hoosier Hot Shots, whose tooting, scraping, and pounding on a weird menagerie of instruments created a unique and popular musical sound. Hailing from Arcadia, Indiana, the foursome recorded countless records and appeared in nearly 20 films. Clockwise from left are Gabe Ward, Paul "Hezzie" Trietsch, Ken Trietsch, and Gil Taylor. The group continued to perform with various lineups into the 1980s. (Courtesy of Chuck Schaden.)

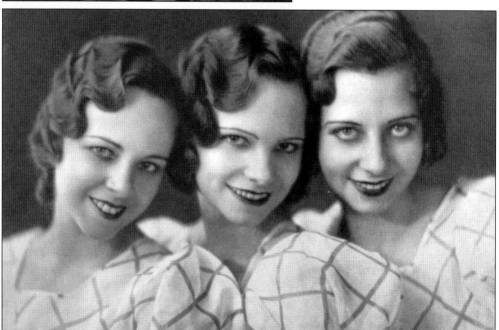

Through a clever use of initials, these three sisters from Joliet, Illinois, formed the singing group known as Winnie, Lou, and Sally. The three sang on many station programs and also toured throughout the Midwest during the Depression era. Their real identities are, from left to right, Helen, Aileen, and Adele Jensen.

Martha Crane's career began in the mailroom at the Prairie Farmer on October 15, 1928. She assumed the pen name Uncle Toby, preparing and editing a weekly children's page for the magazine, but soon was given the opportunity to host a women's program on WLS. Crane would later be named director of women's programs, interviewing hundreds of guests, traveling to farm progress and houseware shows, and reporting on the activities of Chicago area socialites in the latter part of her career at WLS.

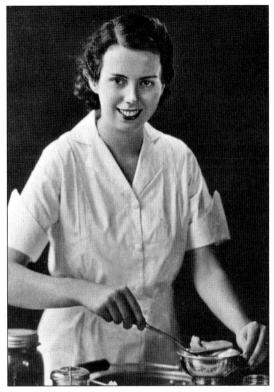

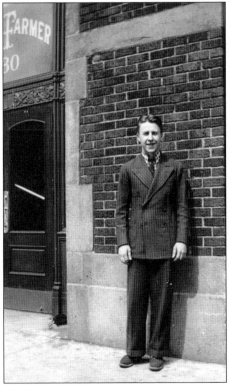

A native Chicagoan, Georgie Goebel became a regular in 1933 at the tender age of 13 when his mother would bring him down to the Eighth Street Theatre for his performances. He enjoyed singing cowboy ballads while wearing a 10-gallon hat and strumming a ukulele, which was not a union instrument, so he avoided the dues! By the 1940s he had his own touring troupe, Georgie Goebel's Barn Dance Band. He also was a first lieutenant in the Army Air Corps during World War II and went on to become a successful comedian, and dropped the *e* to become Gobel. This snapshot was taken in the mid-1930s outside the Prairie Farmer building on Washington Boulevard.

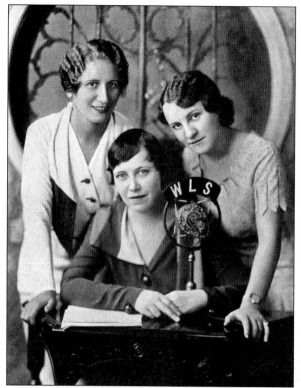

Even after the sale of WLS to the Prairie Farmer, Sears presented programs on the station. *Tower Topics* was aimed mainly at women and aired every Monday from the Sears studio located on Homan Avenue. Sue Roberts, Anne Williams, and Leone Heuer brought listeners topics such as home hints, style and fashion tips, and cooking advice and recipes.

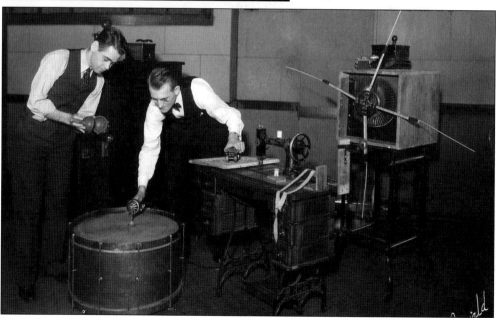

Long before sound effect records and digital effects were available, sounds for radio shows, plays, and productions needed to be generated from scratch and live on the spot. Here a pair of WLS technicians are using the tools of the trade: plungers, cloth, roller skates, a sewing machine, and a bass drum for sound effects. The strange contraption on the right may have been used to generate a wind or airplane sound. (Courtesy of Chris Cline.)

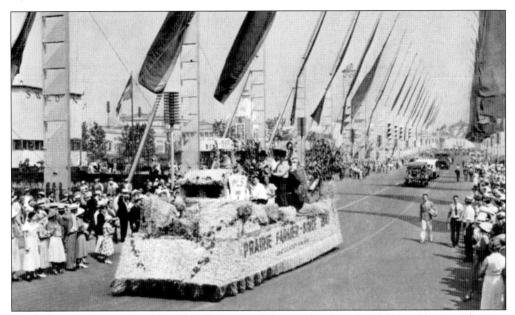

WLS played a large role at the 1933 Century of Progress International Exposition in Chicago. Fair updates began months before its opening. By mid-August, the station devoted 10 percent of its broadcast day to the world's fair. All programming originated at the fair during Farmer's Week, which was heard on the air and throughout the grounds over loudspeakers. This image shows the Prairie Farmer/WLS float in the Farmer's Week parade.

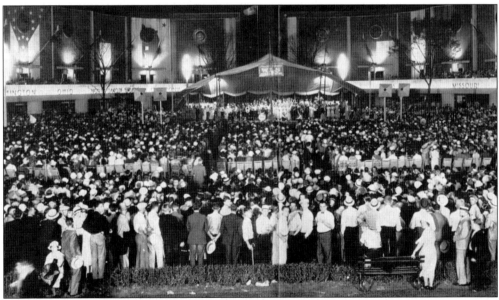

As a part of Farmer's Week, nearly 35,000 spectators attended a special production of the WLS *Barn Dance* at the 1933 Chicago world's fair. It was staged at the Court of the States. All attendance records were broken that week. In fact, it was the biggest *Barn Dance* ever put on. Rufus Dawes, president of the exposition, commented at the time that WLS helped break fair attendance records during Farmer's Week. "Without WLS, this would not have been possible." The *Barn Dance* played at the fair for four successive weeks on Wednesday nights.

WLS promotion director William Cline interviews a guest during Farmer's Week at the Century of Progress International Exposition. Cline was responsible for booking guests, planning features, and organizing schedules during the remote broadcasts. (Courtesy of Chris Cline.)

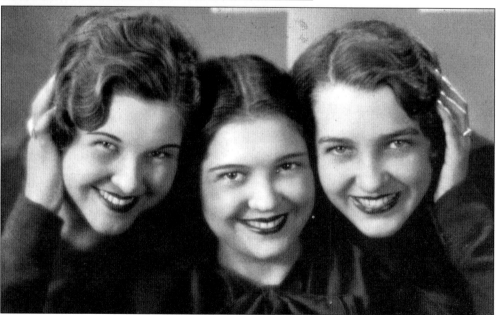

The Three Little Maids was made up of sisters from Decatur, Illinois. Eva, Evelyn, and Lucille Overstake got their start singing at Salvation Army meetings. The trio played to rave reviews and massive crowds during the world's fair in 1933. The group broke up shortly thereafter. Eva was married to Red Foley; Evelyn pursued a solo career, as did Lucille, who changed her name to Jenny Lou Carson.

In 1924, Ralph Waldo Emerson became the first musician to play the organ on a Chicago radio station. Schooled at the Toledo Conservatory of music, Emerson played on the first WLS broadcast and on many shows thereafter. He even married his wife Elsie Mae on the air in 1927.

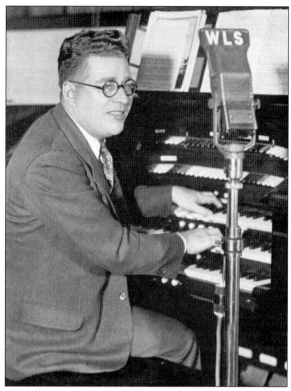

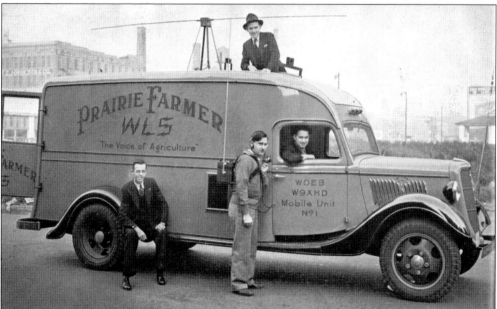

Remote broadcasting equipment was vital to WLS's presentation. Many programs originated away from the main studio microphones. Cornhusking contests, state fairs, news from the markets, and stockyards were all brought back to the station via shortwave remote transmitters. In this 1935 picture, station engineers show off the latest in technology, mobile unit No. 1, complete with transmitter and generator and a "portable" knapsack remote unit.

Julian Bentley was news director through the 1930s and 1940s. His no-nonsense delivery even received praise in a newspaper article by Carl Sandburg. While Bentley and his department served the farmer first, the news took on a wider view when World War II broke out. Bentley, who excelled in world affairs, traveled to England to formalize an affiliation with the BBC at their request. The station also sent its own correspondent to cover the war in Europe.

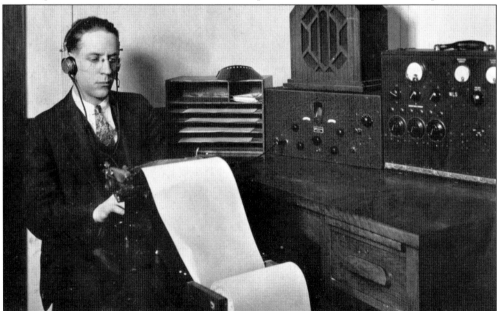

Long before the days of the Internet, press teletypes, and wire services, breaking news was transmitted via shortwave radio. In this 1934 picture, Prairie Farmer WLS shortwave operator M. G. Greiner is typing the news he is receiving in Morse code on the long roll of paper. When a bulletin is received, he types it out and rips it off to give to an announcer. Hence the term "rip 'n read."

Sophia Germanich was born in Prislop, Czechoslovakia, and grew up in the United States. In school, she sang solos with a chorus and in duets. At WLS, Germanich worked as a stenographer until her vocal talents were discovered when she was overheard singing Christmas carols with her coworkers who had formed a chorus. In addition to singing on the air, she then was promoted to work in the music library.

Into the mid-1930s, blackface minstrel performances were still considered acceptable entertainment. Here Malcolm Clair applies makeup while other members of the *Barn Dance* look on in amazement. His character, Spare-Ribs, remained popular through the latter part of the decade.

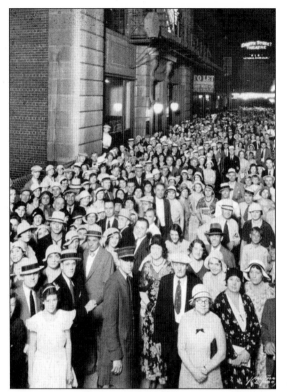

A crowd poses for a picture while waiting on Wabash Street to enter the Eighth Street Theatre in the mid-1930s. Over two and a half million people saw the *National Barn Dance* during its 25-year run at the theater. It first opened in 1908 as the Garden Theatre and was also known as the American Music Hall. The building is still on the site today but has been consolidated into the Hilton Hotel complex and is no longer a venue. Below is a cast picture on stage in the "Old Hayloft."

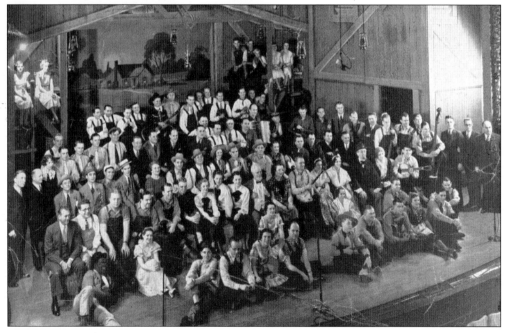

Here is Joe Kelly at the microphone in 1933. He was often referred to as Jolly Joe. A talented announcer, Kelly appeared on a variety of WLS programs, including many children's shows. He was probably best known as the host and master of ceremonies of the *National Barn Dance*. He also hosted the network game show *Quiz Kids*.

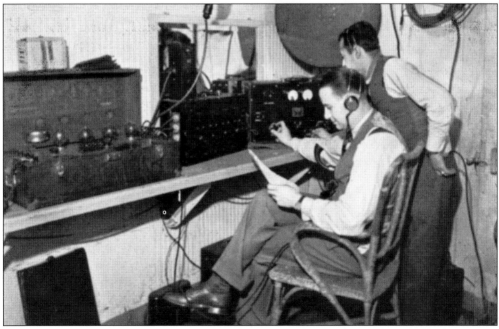

Behind the scenes in a control room at the Eighth Street Theatre, Tom Rowe (left) follows along on the script, knowing exactly when to turn on the microphones and send the audio feed to the main studio during a *National Barn Dance* show in 1932. His assistant to the right is WLS operator Jack "Half-Pint" Pope.

Chosen as one of the three most popular acts on WLS in the mid-1930s, this group consisted of (first row) Jack Taylor, Patsy Montana, and "Salty" Holmes (second row) Chick Hurt and Tex Atchison, originally known as the Kentucky Ramblers. Patsy Montana (originally Rubye Blevens), a native of Arkansas, fronted the group beginning in 1933. Their repertoire included cowboy songs, mountain music, old-fashioned spirituals, and comedy. "I Want To Be a Cowboy's Sweetheart" was a million-selling record.

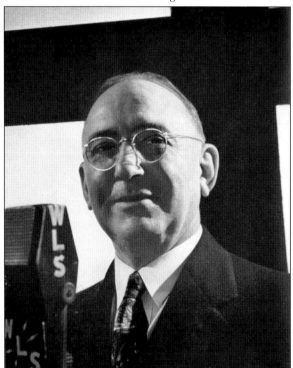

The Reverend Dr. John Holland ministered on WLS via the *Little Brown Church of the Air*, which debuted back in 1925. In 1933, Burridge Butler officially appointed Holland as a full-time staff pastor. His regular service aired on Sundays, and a *Morning Devotion* was heard every morning and at noontime during the *Dinnnerbell* program.

The WLS singers and musicians often played at theaters, fairs, and other venues throughout the Midwest. The bookings were often managed by the WLS Artist Bureau. Here Lulu Belle performs at a state fair in 1937.

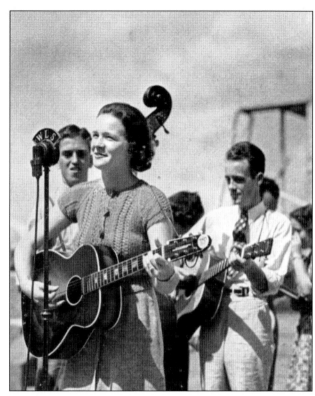

Originally from Winston County, Alabama, Pat Buttram joined WLS and the *National Barn Dance* in 1934. His dry wit and humor would allow him to spin all sorts of stories about his kinfolk from down south. By 1942 he left WLS to make movies and later appeared on television with Gene Autry. Buttram continued on as a nightclub act as well as acting. Many will remember him for his role as Mr. Haney on the 1960s sitcom *Green Acres*.

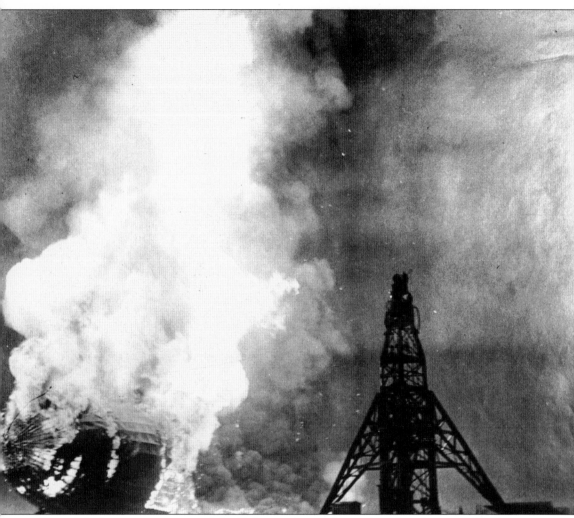

One of the biggest news stories of the 20th century was the crash and explosion of the German airship *Hindenburg* on May 6, 1937. WLS had the only radio reporter on the scene, Herbert Morrison. His anguish was felt when it burst into flames before his eyes and was destroyed in a matter of seconds. "It's bursting into flames. And it's falling on the mooring mast. All the folks agree this is terrible, one of the worst catastrophes in the world. Oh, the flames, four or five hundred feet in the sky, it's a terrific crash ladies and gentlemen. The smoke and the flames now and the frame is crashing to the ground, not quite to the mooring mast. Oh, the humanity and all the passengers." Listeners in Chicago and across the country did not hear Morrison's coverage of the disaster until the next day because his report was not broadcast live from Lakehurst. He and engineer Charles Nehlson had made recordings on huge lacquer discs. The chilling account aired on WLS and was the first recorded radio news report to be broadcast nationally by NBC. (Courtesy of the Lakehurst Historical Society.)

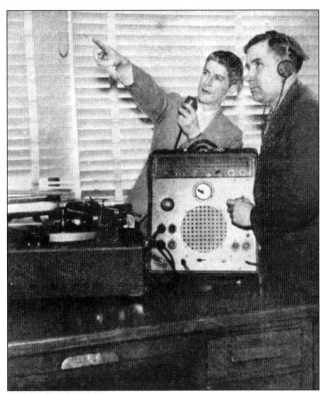

Below, Prairie Farmer/WLS president Burridge Butler presents Herbert Morrison (center) and Charles Nehlson (right) with gold watches for their work in recording the *Hindenburg* disaster. Once Morrison finished describing the scene onto discs, the two realized the gravity of their recordings as they found themselves being followed by German SS officers. After hiding out for a few hours, the two managed to make a clean getaway and get back across the country to WLS. Morrison left in 1939 to join the Mutual Broadcasting System. Nehlson retired from WLS in the late 1960s.

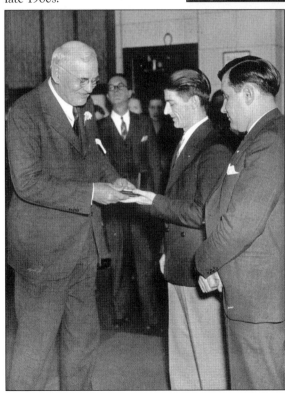

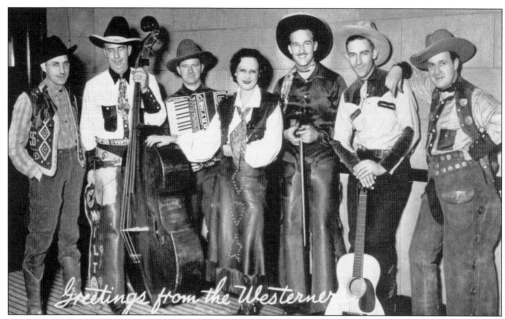

Louise Massey and her Westerners were a family group from Roswell, New Mexico. The bilingual group appeared regularly on the *National Barn Dance* and WLS beginning in 1933 and then again in the early 1940s. One listener in Iowa even kept track of how many songs the Westerners sang: 3,292 songs in person and 501 recordings! (Courtesy of Michael Garay.)

One of the most revered teams in radio during the 1930s and 1940s, Mac (Lester MacFarland) and Bob (Robert Gardner) were both blind. Mac played the piano, coronet, trombone, guitar, and mandolin and later became a music teacher. Bob had a perfect ear for pitch and tone, since he worked as a piano tuner. The two were especially beloved for their singing of hymns on *Morning Devotions* with Dr. John Holland. (Courtesy of Berea College, Southern Appalachian Archives.)

Mary Jane and Carolyn DeZurick developed an astonishing repertoire of high, haunting yodels and yips that soon had them winning talent contests all over central Minnesota as the DeZurick Sisters. They became instant hits at WLS and stayed on for nearly a decade. Both sisters married musicians they had met at WLS, Carolyn to Rusty Gill of the Prairie Ramblers, and Mary Jane to WLS Ranger accordionist Augie Klein. In 1947, when Mary Jane retired, sister Lorraine replaced her.

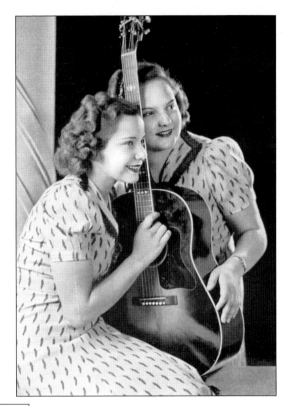

THE WLS CREED

"To me radio is far more than a mere medium of entertainment. It is a God-given instrument which makes possible vital economic, educational and inspirational service to the home-loving men, women and children of America. As long as it is our priviledge to direct the destinies of WLS, we will hold sacred this trust that has been placed in our hands. No medium developed by mankind is doing more to broaden the lives of rich and poor alike than radio.

"When you step up to the microphone never forget this responsibility and that you are walking as a guest into all those homes beyond the microphone."

Burridge D. Butler

November 12, 1938

The WLS Creed was a set of standards written by Burridge Butler to be followed by anyone who appeared on the station. It was such an important document that a bronze plaque hung in the lobby of the Prairie Farmer building.

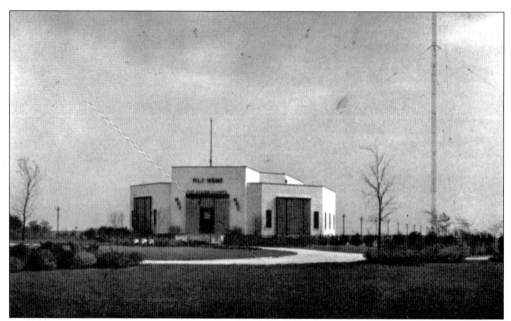

The transmitting facilities were built in 1938 and were jointly owned and operated by WLS and WENR. The two stations shared time on the same frequency, thus utilizing the same transmitting facilities, located near then rural Tinley Park, Illinois. The tower stands 502 feet tall. According to records, the project cost approximately $232,000 at the time of construction. Both the tower and transmitter are still in use today. Interstate 80 now passes to the south of the property.

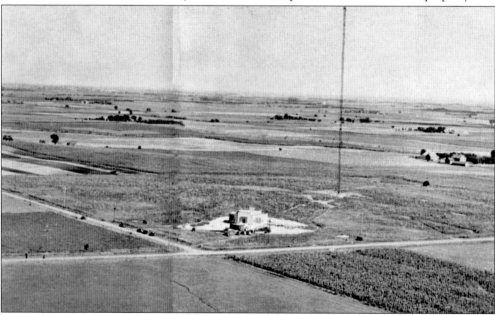

The transmitter site, according to former WLS engineer Marty Soehrman, was picked for several reasons. "In fact, it was *not* chosen for engineering reasons, but because the station owner Burridge Butler, was bickering with Cook County officials. The site was chosen to be as close as they could get to Chicago, but be *outside* of Cook County. It just happened that this was favorable to signal coverage of downstate Illinois."

Jack Stillwill is covering the action during the 1941 National Corn Husking Contest. In addition to radio, he was one of the first to appear on television when the Prairie Farmer gave the first demonstration at the Illinois and Indiana State Fairs in 1939. Stillwill appeared in 1949 as the cohost of the short-lived ABC-TV *Barn Dance*, with Hal O'Halloran.

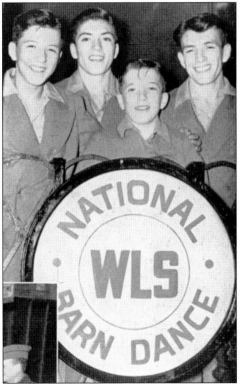

Superstar Andy Williams got his start singing with his brothers on WHO Radio in Des Moines, Iowa. They came to WLS in 1939 and sang on the *Barn Dance* as well as *Smile-A-While* show in the morning. The brothers also went out on tour as a part of the *Barn Dance Special*. Pictured from left to right are Dick, Don, Andy (age 11), and Bob Williams.

45

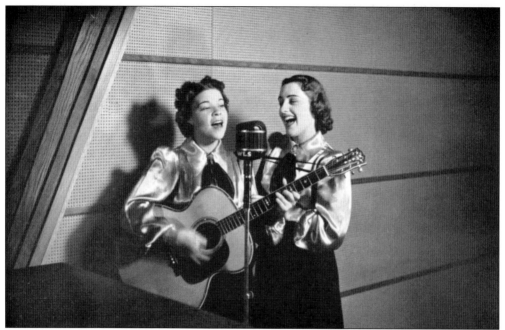

Essie Martin and Kay Reinberg perform in the WLS studio as the duo the Prairie Sweethearts in 1941. The guitar that Martin is playing was built by the Larson company, and it was known as the "WLS Zeke Euphonon." According to the Museum of Musical Instruments, fewer than 30 of them were made and they are considered to be one of the largest and best guitars of the era.

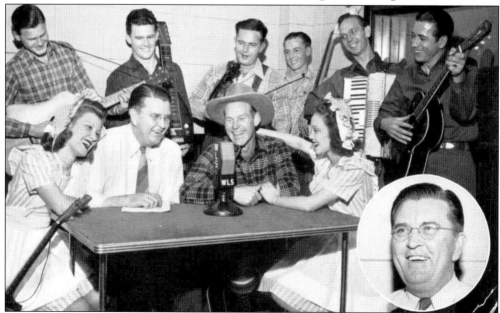

WLS brought live music, comedy, and information to morning audiences on *Smile-A-While*. The show was hosted for many years by Hal O'Halloran (left center and in circle). Considered WLS's chief announcer in the 1930s, he was also a singer with a mellow voice. He was the recipient of the 1933 Chicago Daily Times Most Popular Announcer in Chicago Award. O'Halloran also shared hosting duties on the *National Barn Dance*.

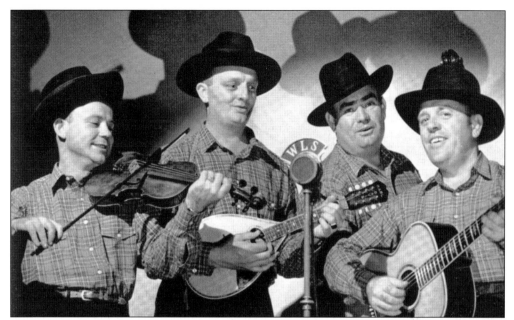

The Cumberland Ridge Runners originally consisted of six members. From left to right, Buddy McDowell, Karl Davis, Hartford Taylor, and Doctor Hopkins are pictured here from 1941. They were billed as the first authentic southern playing-singing act on the *Barn Dance* and WLS. Karl Davis also appeared with Harty Taylor as the duo Karl and Harty.

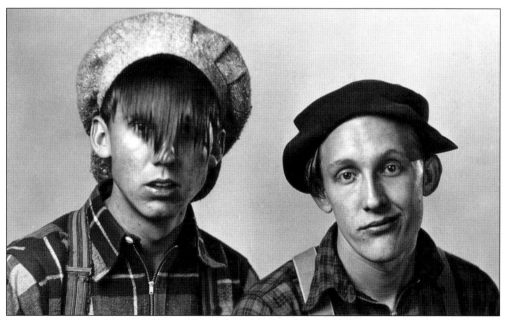

Tennessee natives Homer (Henry Haynes) and Jethro (Kenneth Burns) were musical satirists. The pair specialized in comedic numbers. They gave backwoods twists to popular songs such as "How Much Is That Houn' Dawg in the Winder?" While appearing on the *Barn Dance*, near midnight, Homer and Jethro would often dress in nightgowns and appear with a night lamp to sing a bedtime song. (Courtesy of Berea College, Southern Appalachian Archives.)

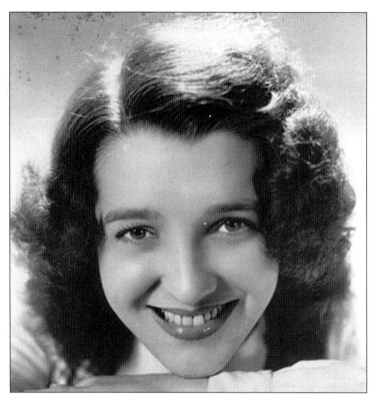

Jenny Lou Carson was originally Lucille Overstake of the Three Little Maids. She briefly joined the trio of Winnie, Lou, and Sally, then changed her name to Jenny Lou Carson in 1939. During World War II, Carson wrote popular songs about soldier boys and home. She was also known as the "Radio Chin-Up Girl" and received plenty of letters from World War II servicemen and their families. Carson's biggest hits included "Jealous Heart" for Tex Ritter and "Let Me Go, Lover," recorded by Patti Page.

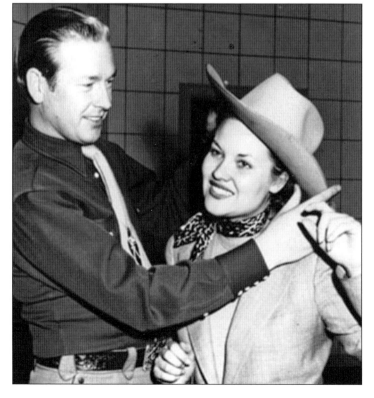

Rex Allen became a regular on WLS for several years following the war. Hailing from Arizona, Allen was a genuine cowboy and his boyish looks made him a *Barn Dance* favorite. Patti Page (born Clara Ann Fowler) also spent time in front of the WLS microphones, just prior to her recording career. (Courtesy of Patti Page.)

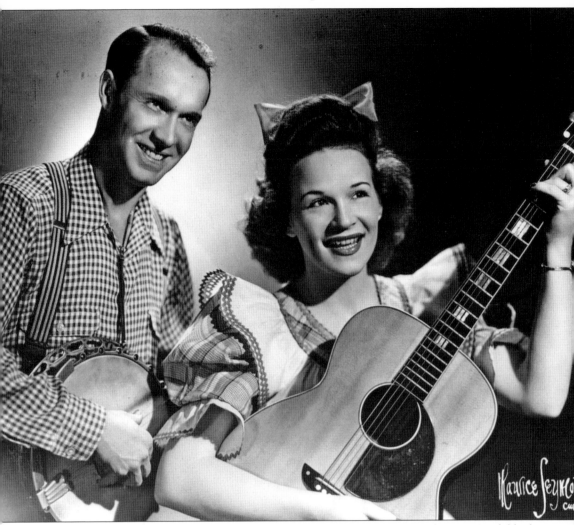

Lulu Belle and Scotty initially appeared on WLS separately. They became a duo in 1934, dubbed America's Sweethearts. When banjo picker and North Carolina mountaineer Skyland Scotty Wiseman married Lulu Belle (Myrtle Cooper), it was feared that the routine they had worked up would come to an end. However, the two became more popular than ever. The duo would spend some 25 years in front of *Barn Dance* audiences at WLS. In 1936, Lulu Belle was voted National Radio Queen. By 1946 the pair had their own television show on Channel 5 in Chicago. In 1975, Lulu Belle was elected to the North Carolina House of Representative on the Democratic ticket. (Courtesy of Chuck Schaden.)

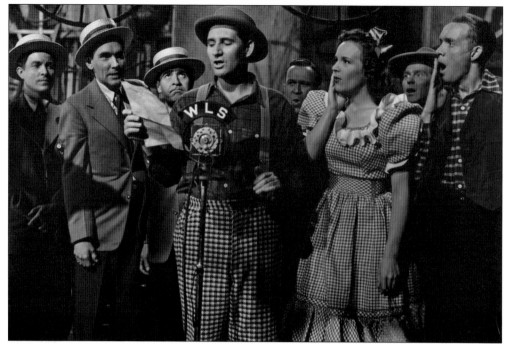

Pat Buttram steps up to the microphone to talk about the goodness of Garvey Soup as the other performers look on in the 1944 Paramount Pictures movie *The National Barn Dance*. The movie starred Charles Quigley (below) as a fast-talking promoter who is looking to put together a radio program featuring "hillbilly performers." He finds Betty (Jean Heather) and the *Barn Dance* gang in a hayloft on Saturday nights in southern Illinois. It featured a host of the WLS stars, including the Hoosier Hotshots, the Dinning Sisters, Joe Kelly, Arkie, and Lulu Belle and Scotty. (Courtesy of Chuck Schaden.)

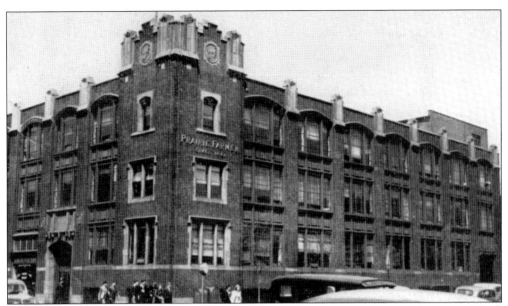

With the amount of musicians, announcers, engineers, and support staff that worked at WLS, along with the Prairie Farmer newspaper employees, the offices at 1230 West Washington Boulevard were a busy place. Below is a floor plan of the WLS offices and studios, which occupied the third floor. The building is now home to an architectural photography company.

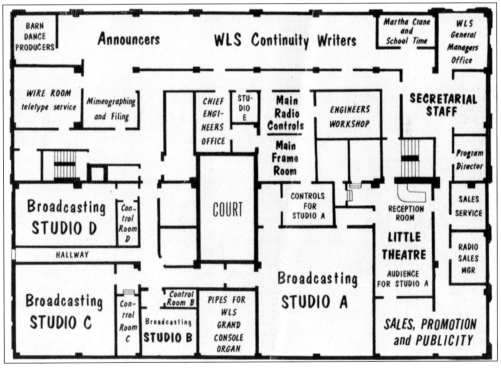

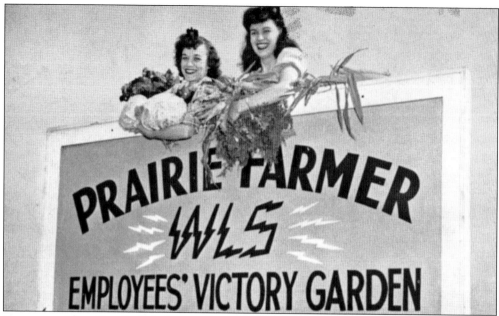

Five acres of Burridge Butler's farm in Burr Ridge, Illinois, were turned into the WLS Prairie Farmer Victory Garden in 1943. Vegetables were grown, harvested, and canned by the employees for their consumption. Plus it provided experience to those who had never worked on a farm. Gazing at the progress over the sign are Isabelle Cooke of the editorial department and engineering secretary Mildred Zalac.

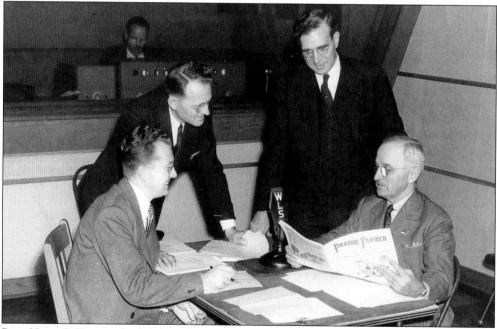

Pres. Harry S. Truman (right) drops by the WLS studios and after his interview takes a break to read the latest edition of the *Prairie Farmer* magazine. Also pictured from left to right are WLS promotion director Bill Cline, program director Harold Safford, and associate editor and farm director Arthur C. Page. (Courtesy of Chris Cline.)

Clyde "Red" Foley was a member of the Cumberland Ridge Runners as a vocalist and guitarist. He left the group to return to Kentucky, but came back to WLS a few years later. He was paired up with Myrtle Cooper, who would later become Lulu Belle. By 1941, Foley signed a record deal and became a major recording star. Foley's daughter Shirley Lee has been married to actor and singer Pat Boone since 1953.

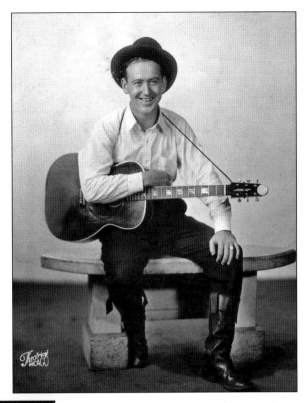

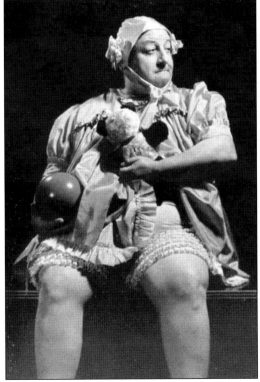

His real name was Ted "Otto" Morse, a talented trumpet player. But for the *National Barn Dance*, this man donned a ruffled baby dress and bonnet to portray Little Genevieve, the crybaby, throughout the 1940s. "She" would attempt to sing, but when her songs were panned, Little Genevive would begin to cry loudly. Morse was also a member of the comedy instrumental group known as the Virginia Hams.

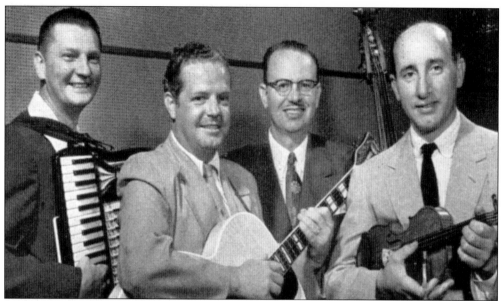

Johnny Frigo and the Chore Boys are seen here in 1954. After World War II, Frigo hit the road as Jimmy Dorsey's bassist and played with Chico Marx. Despite his significant reputation as a jazz bass player and violinist, he immediately mastered country fiddling when a job opened up at WLS in 1948. After WLS, Frigo has gone on to become one of the world's leading jazz violinists and wrote many songs, including "Hey, Hey, Holy Mackerel" to honor the Chicago Cubs in 1969. From left to right are Augie Klein, Jimmy Hutchinson, Tony Nix, and Frigo.

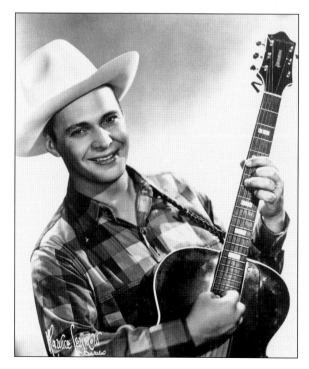

Hailing from Snuff Hollow, Pennsylvania, Dolph Hewitt was not only a singer but also a yodeler and played the fiddle. Press releases touted that Hewitt's robust strains were self-taught while he cleared timber as a young man, and that he has actually rivaled singing canaries and has sung with them. Hewitt's theme song was "When You Hear Me Call."

Donald "Red" Blanchard got his start on the *Barn Dance* as a part of the Texas Cowboys but branched out on his own in later years. Blanchard had a unique ability to tell tales and spin yarns in a comedic fashion. In 1949, he was made honorary mayor of his hometown of Pittsville, Wisconsin. He stayed with WLS to the end and moved with the *Barn Dance* over to WGN in the 1960s.

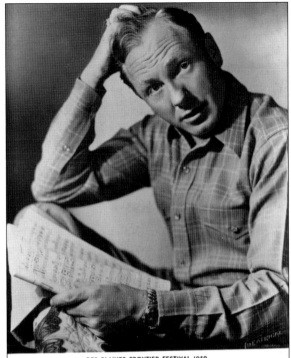

DES PLAINES FRONTIER FESTIVAL 1950

DONALD "RED" BLANCHARD WLS NATIONAL BARN DANCE

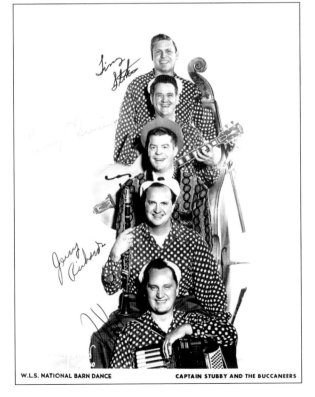

W.L.S. NATIONAL BARN DANCE CAPTAIN STUBBY AND THE BUCCANEERS

Tom Fouts, also known as "Captain Stubby," is pictured with the Buccaneers. The group first performed the original Roto-Rooter jingle on WLS in the early 1950s. The recorded version became one of the longest-running tunes in the history of advertising. Captain Stubby stayed on as a cohost of the WLS Farm Special show (with Chuck Bill), which aired every morning until 1968. Pictured from top to bottom are Tiny Stokes, Sonny Fleming, Fouts, Jerry Richards, and Peter Kaye.

55

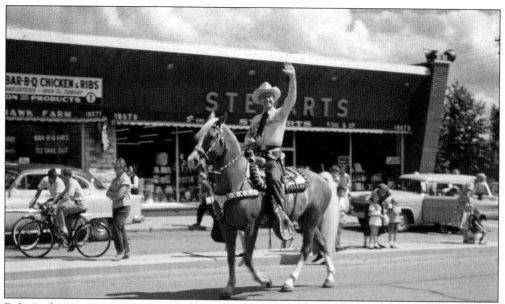

Bob Atcher came to WLS with over 300 recordings under his belt. And his belt matched his penchant for ornate shirts—some costing upwards of $250 apiece! He also sported an expensive palomino and a handmade silver mounted saddle. He went on to become the mayor of Schaumburg, Illinois, from 1959 to 1975. Atcher is pictured riding his horse Golden Storm in a parade along Dixie Highway in south suburban Homewood, in the late 1950s. (Photograph by Frank Crescenzi.)

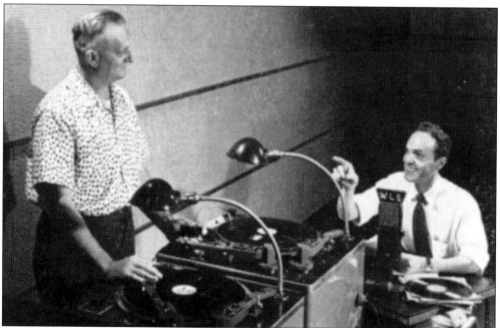

By the mid-1950s, live performances began to dwindle during the week, replaced by recorded music. Here announcer Jack Brinkley (right) cues record turner Karl Davis, formerly of Karl and Harty and the Cumberland Ridge Runners, for the next selection. Davis stayed with WLS long after the switch to rock as a record turner and was a genuine Kentucky colonel.

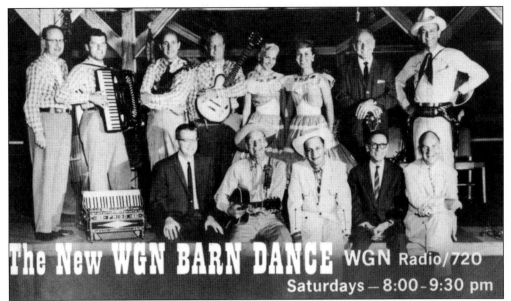

When WLS cancelled the *National Barn Dance* in 1960, the show moved over to WGN. It aired on WGN AM and television on Saturday nights for nine years. Many of the WLS talent moved over to the new station. From left to right are (first row) WGN announcer Orion Samuelson, Arkie, Dolph Hewitt, Harold Turner, and Al Rice; (second row) Toby Nix, Lino Frigo, Johnny Frigo, Jimmy Hutchinson, Ruth and Edith Johnson, Red Blanchard, and Bob Atcher. (Courtesy of Michael Garay.)

On Sunday, May 1, 1960, this advertisement appeared in the morning Chicago newspapers. The last *National Barn Dance* aired on WLS the night before and the next day would bring radical changes to the station that broadcast farm programming for the past 36 years. *Mid-America's Bright New Sound* would debut Monday morning at 6:00.

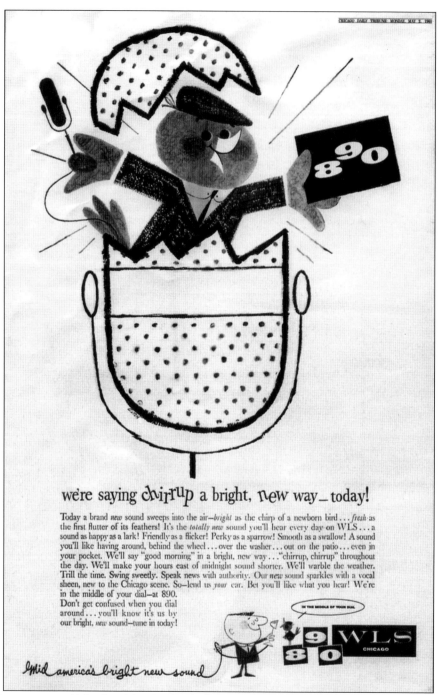

On the morning of Monday, May 2, 1960, Chicago and the Midwest awoke to new sounds on 890 kHz. For the first time in 36 years, there were no fiddles or accordions, no rural homespun chatter. Instead, it was the sound of the urban city and modern times. This advertisement in the *Chicago Tribune* heralded "Our new sound sparkles with a vocal sheen, new to the Chicago scene." WLS was about to embark on a 29-year rock 'n' roll ride that would propel it into radio history as one of the most popular stations on the planet.

Three

THE BRIGHT NEW SOUND

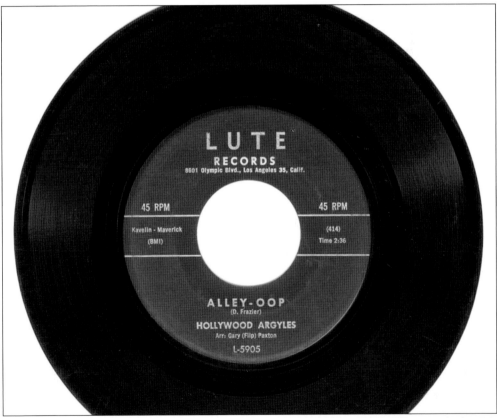

In 1960, the American Broadcasting Company/Paramount Theatres took full control of WLS. It was on a mission to modernize. The first song played after WLS changed format from farm programming to contemporary music was the one-hit wonder "Alley Oop" by the Hollywood Argyles. Was there any special reason that this song was picked to air first on the new station? Probably not—it was already on the charts on May 2 and reached the number one spot on July 11, 1960.

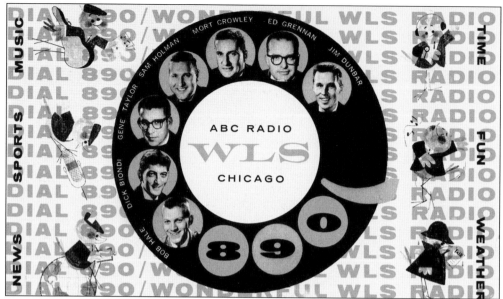

Here the original "Swingin' Seven" disc jockeys are featured "around the dial" in 1960. Clockwise from left to right are *East of Midnight* host Bob Hale, Dick Biondi (9:00 p.m.–midnight), Gene Taylor (7:15 p.m.–9:00 p.m.), Sam Holman (3:00 p.m.–6:30 p.m.), Mort Crowley (noon–3:00 p.m.), Ed Grennan (10:00 a.m.–noon), and Jim Dunbar (6:00 a.m.–9:00 a.m.). Grennan, a holdover from the *Prairie Farmer* format, stayed with the new format for only six months and later admitted that he felt that he "didn't fit in" with the new sound. He went on to a long and successful career at WMAQ radio and television.

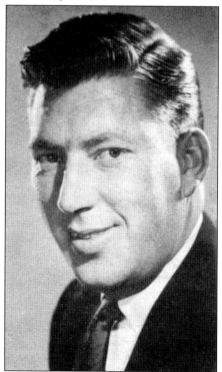

Ralph Beaudin was named WLS president and general manager in March 1960. He was brought in from ABC sister station KQV Pittsburgh to completely revamp WLS's programming. His blueprint brought new success to the station. In 1962, Beaudin was named Radio Man of the Year by the American College of Radio Arts. After leaving WLS, Beaudin was one of the men responsible for developing ABC Radio's four-network system.

WLS
silver dollar survey
CHICAGO'S ONLY AUTHENTIC RECORD SURVEY
October 14, 1960

THIS WEEK			LAST WEEK
1.	SHORTNIN' BREAD	Paul Chaplain — Harper	
2.	MR. CUSTER	Larry Verne — Tra	
3.	MY HEART HAS A MIND OF ITS OWN	Connie Francis — MGM	
4.	YOU TALK TOO MUCH	Joe Jones — RIC	
5.	IT'S NOW OR NEVER	Elvis Presley — RCA	
6.	NEVER ON SUNDAY	Don Costa — UA	
7.	HOT ROD LINCOLN	Johnny Bond — Republic	
8.	SO SAD	Everly Brothers — Warner	
9.	YOU MEAN EVERYTHING TO ME	Neil Sedaka — RCA	
10.	LET'S THINK ABOUT LIVING	Bob Luman — Warner	
11.	SAVE THE LAST DANCE FOR ME	Drifters — Atlantic	
12.	STAY	Maurice Williams — Herald	
13.	TWISTING U.S.A.	Danny & Jrs. — Swan	
14.	GEORGIA ON MY MIND	Ray Charles — ABC	
15.	DEVIL OR ANGEL	Bobby Vee — Liberty	
16.	PINEAPPLE PRINCESS	Annette — Vista	
17.	CHAIN GANG	Sam Cooke — RCA	
18.	WAIT FOR ME	Playmates — Roulette	
19.	THE LAST ONE TO KNOW	Fleetwoods — Dolton	
20.	KOOKIE LITTLE PARADISE	Joe Ann Campbell — ABC	
21.	WALK—DON'T RUN	Ventures — Dolton	
22.	COME HOME—COME HOME	Sheppards — Apex	
23.	THREE NIGHTS A WEEK	Fats Domino — Imperial	
24.	TONIGHTS THE NIGHT	Chiffons — Big Deal	
25.	SLEEP	Little Willie John — King	
26.	I WANT TO BE MARRIED	Brenda Lee — Decca	
27.	OVER YOU	Arron Neville — Minit	
28.	I LOVE YOU IN THE SAME OLD WAY	Paul Anka — ABC	
29.	VOLARE	Bobby Rydell — Cameo	
30.	ANY MORE	Teresa Brewer — Coral	
31.	ALVIN FOR PREXY	Chipmunks — Liberty	
32.	GIRL WITH A STORY IN HER EYES	Safaris — Eldo	
33.	YOU WANT LOVE	Clyde Stacy — Bullseye	
34.	MOVE TWO MOUNTAINS	Marv Johnson — UA	
35.	SHIMMY LIKE KATE	Olympics — Arvee	
36.	DIAMONDS & PEARLS	Paradons — Milestone	
37.	HARMONY	Billy Bland — Old Town	
38.	DON'T BE CRUEL	Bill Black — Hi	
39.	DON'T YOU JUST KNOW IT	Fendermen — Soma	
40.	SOMEBODY TO LOVE	Bobby Darin — Atco	

FEATURE ALBUM OF THE WEEK
A LOT OF DOMINOS Fats Domino — Imperial

Swing Along with the
Gene Taylor
Show
7:15 to 9:00 P.M. — Monday thru Saturday

WLS · DIAL 890 · 24 HOURS-A-DAY
ABC RADIO IN CHICAGO

This survey is compiled each week by WLS Radio/Chicago from reports of all record sales gathered from leading record outlets in the Chicagoland area. Hear Sam Holman play all the SILVER DOLLAR SURVEY hits daily from 3:00 to 6:30 P.M.

The WLS Music Survey spanned nearly 30 years. During this time, the colorful sheet issued weekly to inform Chicagoans what songs were hot changed names and formats several times. This was the first survey that was issued, on October 14, 1960, a little over five months after the station flipped to contemporary music. WLS counted down all the hits on the *Silver Dollar Survey* every afternoon throughout the 1960s. According to Clark Weber, "[program director] Sam Holman chose the name 'Silver Dollar' Survey with the idea that silver dollars were highly valued in those days and most people held on to them. It's strange that today when ever I'm asked to autograph an old survey, it's a Silver Dollar Survey and not a Hit Parade Survey."

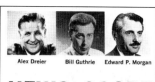

Alex Dreier Bill Guthrie Edward P. Morgan

NEWS-SCOPE

Chicago's #1 News Show

6:30 - 7:30 PM
WEEKDAYS

6:30 — Alex Dreier — News

6:40 — Local News — Bill Guthrie

6:45 — Commentary — Norman Ross

6:50 — Speaking of Sports—H. Cosell

6:55 — Business Final—H. Wittenberg

7:00 — Edward P. Morgan — News & Comment

7:15 — Weather — John Cameron Swayze

7:20 — ABC News — Bill Sheehan

7:25 — From the Editor's Desk — Bill Guthrie

WLS

The bright sound of Chicago Radio

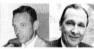

Norman Ross Bill Sheehan John C. Swayze

WLS's news department was known as one of the best in Chicago. This 1962 schedule illustrates just some of the local and national information they provided on a daily basis. Updates aired at 25 and 55 past each hour. WLS boasted that it aired 58 newscasts every day. It employed at least eight wire services and a huge newsroom staff that consisted of five newscasters, four news writers, and a news director.

Pictured here at a 1997 reunion are a few WLS newscasters of the 1960s. From left to right are Mort Crim, Jerry Mitchell, and Jerry Golden. Mitchell and Golden signed on when WLS was still owned by Prairie Farmer. In 1963, it was Golden who broke the news on WLS that Pres. John F. Kennedy had been assassinated. Crim went on to become a national journalist and commentator. (Courtesy of Michaela Nelson.)

Dick Biondi, the "Wild I-tralian," exploded in Chicago and all across North America in 1960, thanks to WLS's huge 50,000-watt signal at night. He introduced millions of kids to rock-and-roll music and had a fan club that totaled into the thousands. His "Pizza Song" was based on the classic "On Top of Old Smokey." The record sold over 11,000 copies. Biondi only stayed at WLS for three years. Contrary to popular belief, it was not because he told a dirty joke. He was very concerned about the high amount of commercials and news he had to run, and he let his displeasure be known to the sales manager. As a result, a literal fistfight ensued in the hallway of the station. After it was over, Biondi and management decided to part ways.

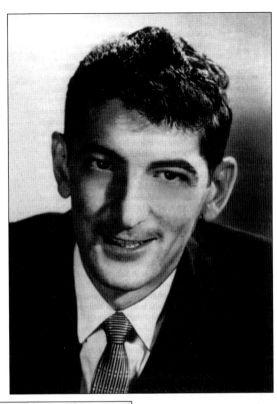

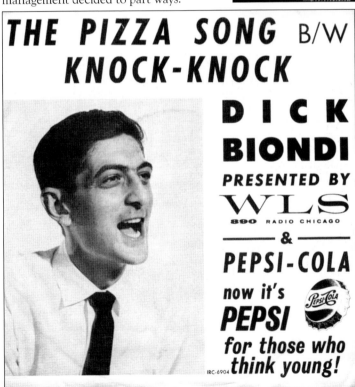

THE PIZZA SONG B/W
KNOCK-KNOCK

DICK BIONDI

PRESENTED BY

WLS
890 RADIO CHICAGO

— & —

PEPSI-COLA

now it's
PEPSI

for those who
think young!

IRC-6904

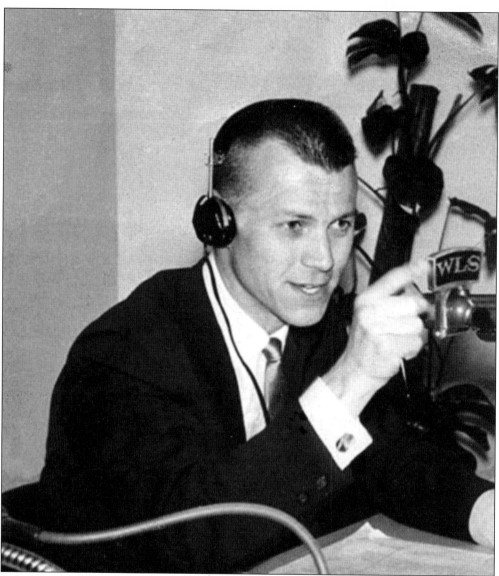

Bob Hale spent four years at WLS, beginning in 1960. "The midnight shift was incredible—we reached 42 of the 50 states." Prior to WLS he worked in Mason City, Iowa, at KRIB. In February 1959, Hale was master of ceremonies of the Winter Dance Party in Clear Lake, Iowa, after which Buddy Holly, Ritchie Valens, J. P. Richardson (known as the Big Bopper), and pilot Roger Peterson were killed in the plane crash that made news headlines around the world. It is an event that has been called "the Day the Music Died." According to Hale, "I was pulling the 9 to noon shift [the day after the crash] and teens began arriving at the station just to talk. It became a day-long wake." After moving on from WLS, Hale hosted the television show *Today in Chicago* on Channel 5 from 1967 to 1983. (Courtesy of Bob Hale.)

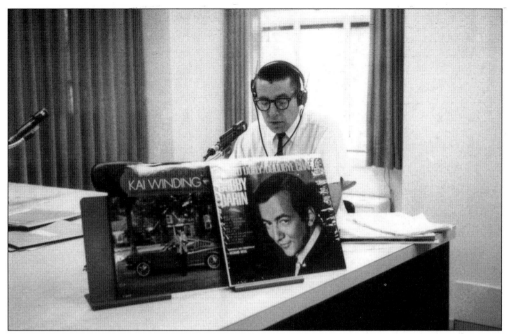

Here is Gene Taylor on the air in the WLS studio in 1964. Taylor made the most of the career ladder at the station. He was one of the original seven who signed on in 1960. In 1961, he became the program director and left the air for the position of station manager in 1965. A year later Taylor was promoted to general manager, a position he held for five years.

Officer Vic Petrulis was an active Chicago police officer who doubled as a WLS traffic reporter and a public safety announcer. He was also very popular with the listeners. "Of all the WLS personalities, Vic got the most requests to appear at the various record hops!" noted Clark Weber.

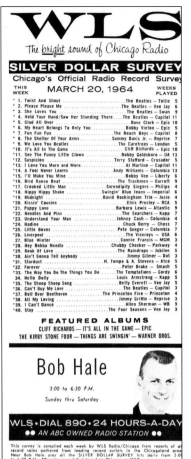

Beatlemania was running rampant in Chicagoland in March 1964. They not only held down the top four spots with five songs on the *Silver Dollar Survey* but also had another song moving up. Plus, songs like "Liverpool" by the Viceroys and "We Love You Beatles" by the Carefrees also made the Top 40 chart.

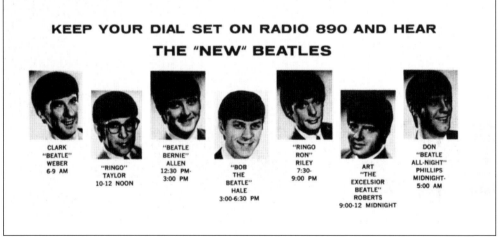

WLS jumped on the Beatles bandwagon in a big way. WLS was the first station in the United States to play "Please Please Me" on February 22, 1963. Ron Riley would often have their newest songs on the air before they were released in America, thanks to some contacts in England that would send them overseas. Riley also hosted a music show called *The British Billboard*.

Known as "the crew cut fellow in the first row," Dex Card came to WLS in 1964 and was assigned the afternoon shift from 3:00 p.m. to 6:30 p.m. During the week, he counted down the songs on the WLS *Silver Dollar Survey* show. After Card left the station in 1967, he went on to the teen club and concert business. He also owned radio stations along the way, including several in Wisconsin. And, yes, Dexter Card is his real name! (Courtesy of Clark Weber.)

Before the age of the Internet and video on demand, one of the ways that radio stations connected to their listeners was with record hops (also known as sock hops). These dances would be held at local schools, churches, or community centers and would be often hosted by a station personality. Dex Card would appear at several WLS record hops a week, due to his availability in the evenings after his on-air shift.

Nighttime personality Art Roberts (right) poses with Gary Lewis (center) and the Playboys after an on-air interview. In 1966, the group was very popular after riding high on the WLS *Silver Dollar Survey* with "This Diamond Ring" and "Count Me In."

Have you heard...
COMMUTER CONTROL CENTRAL

A morning digest of all the latest news, traffic information and weather designed for your family . . . weekdays at 6:25, 7:25 and 8:25 AM exclusive on

WLS
DIAL 890
The bright sound of Chicago Radio

As the Chicagoland area expressways and tollways were competed by the mid-1960s, WLS was one of the first stations to air traffic reports. Initially reports were aired only three times daily. Over the years, the frequency increased and the methods were modernized. By the 1970s, traffic was reported mornings and afternoons. In the 1980s, Don Nelson provided live helicopter reports. He also was a part-time air talent on WLS.

This was a typical Saturday during the 1960s on the fifth floor at 360 North Michigan Avenue. The viewing room was open from 1:00 a.m. to 3:00 p.m., and many fans ventured to the station to see their favorite WLS personality and sometimes get a glimpse of a recording artist or celebrity who might be in town for an interview.

Dick Clark (left) signs a balloon for a young lady, along with nighttime host Art Roberts (right) in the WLS viewing room. The students were journalism majors and student newspaper reporters who were invited to interview Clark and Roberts at the station in 1966.

One of the reasons that WLS was so successful during the rock era was that the personalities on the air were allowed to have a good time. Here in 1966 is the shift change between Art Roberts (left) and Ron Riley, clutching an armful of albums, including "If You Can Believe Your Eyes and Ears" by the Mamas and the Papas. Roberts was just beginning his show as Riley was on the way out.

The *Wild Adventures of Peter Fugitive* was a daily radio serial that featured espionage, suspense, and intrigue. The episodes aired during Art Roberts's show and were produced by WLS production director Ray Van Steen. He played the part of Peter, as well as his faithful sidekick Bobby. Van Steen arranged all the voices, music, and sound effects for the serial.

One of the most intriguing situations on WLS in the 1960s was the "feud" between morning man Clark Weber and evening jock Ron Riley. The make-believe feud (which sounded very real on the air) actually began when the two worked for competing radio stations in Milwaukee, prior to coming to WLS. It was an ingenious ploy to get people to listen both in the mornings and evenings to find out what barbs they would throw at the other. The two even formed their own fan camps—Weber's Commandos and Riley's Raiders. While the battle played out over the air, in reality the two had a difficult time appearing together socially as listeners would gossip. In this publicity picture, the WLS air staff is trying to keep the two from tearing each other apart. Counterclockwise from left are Bernie Allen, Don Phillips, Art Roberts, Weber, Riley, and Dex Card.

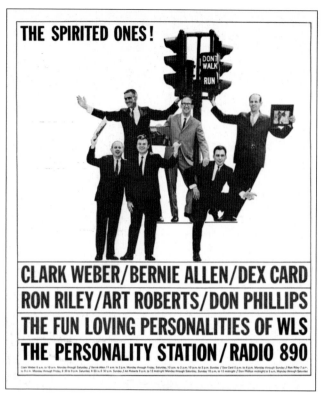

THE SPIRITED ONES!

CLARK WEBER/BERNIE ALLEN/DEX CARD
RON RILEY/ART ROBERTS/DON PHILLIPS
THE FUN LOVING PERSONALITIES OF WLS
THE PERSONALITY STATION/RADIO 890

Here is a newspaper and magazine advertisement from 1966.

Don Phillips, or as he was nicknamed "Dimple Donnie," held down the all-night show, which was referred to as *East Of Midnight*. While the overnight shift may sound lonely, Phillips knew he had a big audience. "We'd get calls and letters from doctors, nurses, firemen, policemen, and thousands of others who work while the rest of the world is asleep. I have had listeners call from as far away as Texas and California."

Clark Weber is seen boogying
with Mary Jane Mangler, a
"slaygirl" from the spy-spoof movie
Murder's Row, starring Dean
Martin and Ann-Margaret. WLS
hosted the premiere party at the
Bratskellar in 1966. (Courtesy of
Clark Weber.)

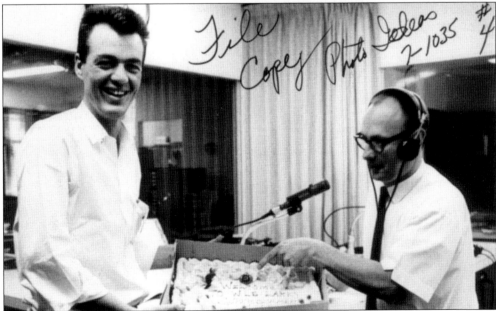

Larry Lujack is being presented with a welcome cake on his first day at WLS from midday host
Bernie Allen in April 1967. He had just come over from doing the all-night show at rival WCFL.
Lujack said in his biography, "On my first show at WLS, I tore the place apart, burned up the
airwaves for four hours, really feeling good!" Lujack would stay for five years before returning to
Super 'CFL as afternoon host.

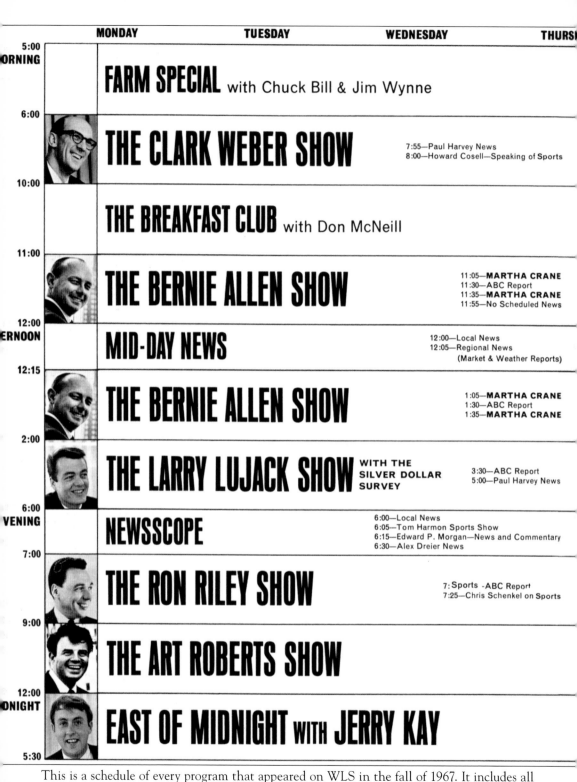

	MONDAY	TUESDAY	WEDNESDAY	THURS

5:00
MORNING

FARM SPECIAL with Chuck Bill & Jim Wynne

6:00

THE CLARK WEBER SHOW

7:55—Paul Harvey News
8:00—Howard Cosell—Speaking of Sports

10:00

THE BREAKFAST CLUB with Don McNeill

11:00

THE BERNIE ALLEN SHOW

11:05—**MARTHA CRANE**
11:30—ABC Report
11:35—**MARTHA CRANE**
11:55—No Scheduled News

12:00
AFTERNOON

MID-DAY NEWS

12:00—Local News
12:05—Regional News
(Market & Weather Reports)

12:15

THE BERNIE ALLEN SHOW

1:05—**MARTHA CRANE**
1:30—ABC Report
1:35—**MARTHA CRANE**

2:00

THE LARRY LUJACK SHOW WITH THE SILVER DOLLAR SURVEY

3:30—ABC Report
5:00—Paul Harvey News

6:00
EVENING

NEWSSCOPE

6:00—Local News
6:05—Tom Harmon Sports Show
6:15—Edward P. Morgan—News and Commentary
6:30—Alex Dreier News

7:00

THE RON RILEY SHOW

7:Sports -ABC Report
7:25—Chris Schenkel on Sports

9:00

THE ART ROBERTS SHOW

12:00
MIDNIGHT

EAST OF MIDNIGHT WITH **JERRY KAY**

5:30

This is a schedule of every program that appeared on WLS in the fall of 1967. It includes all the music shows, news, sports, and public affairs programming. In 1968, the station would drop

	FRIDAY	SATURDAY	SUNDAY	
			EAST OF MIDNIGHT WITH JERRY KAY	5:00
				5:30
			5:30 NEGRO COLLEGE CHOIR ABC	
			6:00 PILGRIMAGE	
			6:30 CHRISTIAN IN ACTION	
			7:00 QUINCY COLLEGE	
			7:30 CAREERS UNLIMITED	
		8:25, 9:25—World of Sports	**8:00 CHRISTIAN SCIENCE**	
			8:15 VIEWPOINT	
			8:30 BACK TO GOD	
			9:00 HOUR OF DECISION 9:25—World of Sports	10:0
		10:25—World of Sports 11:25—World of Sports	**9:30 GOOD NEWS** Church Federation of Chicago	
			9:45 AT WORSHIP IN CHICAGO Church Federation of Chicago	
			10:00 MESSAGE OF ISRAEL ABC 10:25—World of Sports	
			10:30 SCIENCE AND THE CHALLENGE University of Illinois, Medical Research Center	
			11:00 PEOPLE'S CHURCH Dr. Preston Bradley	
				12:0
	—National News	**PAUL HARVEY NEWS**	**THE BERNIE ALLEN SHOW** 12:25—World of Sports 1:25—World of Sports	12:1
		12:25—World of Sports 1:25—World of Sports		
				2:0
		2:25—World of Sports 3:25—World of Sports 4:25—World of Sports 5:25—World of Sports	2:25—World of Sports 3:25—World of Sports 4:25—World of Sports 5:25—World of Sports	
	—Local Sports	**MAN ON THE GO / DREIER**	**MAN ON THE GO / DREIER**	6:0
	—Business News Final—Harvey Wittenberg	**TOM HARMON SPORTS** 6:25—ABC News	**TOM HARMON SPORTS** 6:25—ABC News	6:1
	—"On the Line"—Bob Considine	7:25—World of Wheels	**THE RON RILEY SHOW**	6:3
	—ABC News	8:25—World of Sports	7:25—World of Sports 8:25—World of Sports	
				8:3
			CHICAGO PORTRAIT	9:0
			PINPOINT	9:3
			SILHOUETTE	
		9:25—ABC Sports 10:25—Weekend Sports	**THE ART ROBERTS SHOW** 10:25—World of Sports 11:25—World of Sports	10:0
				12:0
			MIDNIGHT UNTIL 5:00 AM— SIGN OFF FOR MAINTENANCE	

the news blocks and *Don McNeill's Breakfast Club* show to add more music. The competition with WCFL AM 1000 began in 1965 and was in full swing.

By the time she retired in 1969, Martha Crane had easily become the longest-tenured employee at WLS Radio, over 40 years. She was also the longest continuous woman broadcaster in the United States. Over 12,000 guests, from presidents to homemakers, appeared on her shows over the years. In 1960, Crane was the recipient of the Headliner Award, given by the Association for Women in Communications to recognize her outstanding achievements.

Jerry Kay was brought in shortly after Larry Lujack was hired in 1967. They had both worked together at KJR Radio in Seattle. "He was hip, he was funny, he was consistent, he was simply wonderful," said Pat O'Day, one of Jerry's program directors. "He could employ a very syrupy sound, with his cutting sarcasm." Kay would bill himself as "the nice man on the radio."

Here is the WLS air staff in 1969. From left to right are (first row) Kris Erik Stevens, Bill Bailey, and Chuck Buell; (second row) Art Roberts, Larry Lujack, and Jerry Kay.

John Rook was brought in to program WLS in 1967. He is credited with hiring air personalities Kris Erik Stevens, Chuck Buell, and newsman Lyle Dean. Rook proudly announced that "We were named radio station of the year by [radio publication] Gavin Magazine in 1968. During this period of time, no Chicago radio station out-rated WLS." Rook is pictured with singer Bobby Vee (right) in 1968. (Courtesy of John Rook.)

By the early 1970s, times had changed and WLS had begun to change as well. Program directors like John Rook and Mike McCormick were given mandates to keep the station current and relevant. The local garage bands were pushed aside for corporate rock and pop. The Motown sound gave way to soul, funk, and later, disco. The original Swingin' Seven jocks had moved on, and a new crop of young hosts replaced them, many that would become broadcasting elite. WLS reflected these changes. Once known as "Radio 8-9-0" and "the Bright Sound of Chicago Radio," it became "the Big 89." WLS was now "the Rock of Chicago."

Four

THE ROCK OF CHICAGO

By the 1970s WLS was the dominant station, not only in Chicago but across the Midwest. Ratings services such as Arbitron measured over three million WLS listeners in Chicagoland and nearly six million all across the United States. The station, in heated competition with WCFL, would be beaten by them only once. By 1975 'CFL changed formats, leaving WLS as "the Only One," as illustrated in this downtown billboard. (Courtesy of John Gehron.)

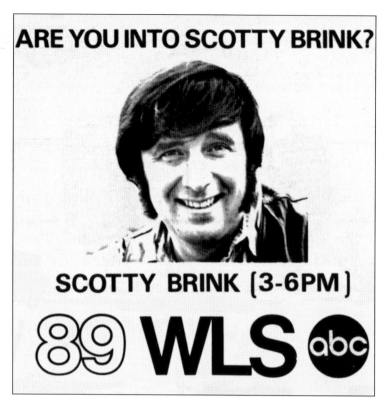

ARE YOU INTO SCOTTY BRINK?

SCOTTY BRINK (3-6PM)

89 WLS abc

Scotty Brink got his radio start while still in high school in Williamsport, Pennsylvania. He also spent time behind the microphone in Los Angeles, New York, Philadelphia, and in Vietnam with Armed Forces Radio. Brink came to WLS in 1970 from rival WCFL.

Meanwhile Dick Biondi made his way back to Chicago several years after he left WLS. Beginning in 1967, he spent five years competing against his former employer at WCFL. Prior to his return, Biondi did a syndicated radio show that aired on over 100 radio stations. He is pictured here in the "Big 10" Marina City studios in 1972. (Courtesy of the Chicago Sun-Times.)

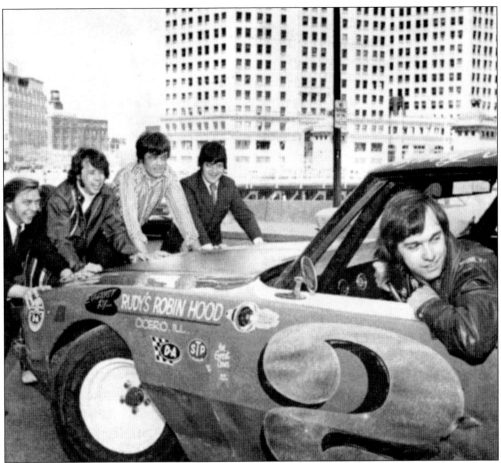

This 1971 promotional picture was staged on Wacker Drive for the sponsor U.S. 30 Dragstrip, located in Hobart, Indiana. The drag strip ran memorable commercials on WLS for many years featuring voice-overs by Jan Gabriel. "Sunday, Sunday, Sunday! At Smokin' US 30 Dragstrip—where the great ones—run, run, run!" Mr. Norm, the Chi-Town Hustler, and "Big Daddy" Don Garlits were perennial favorites that were often advertised. Pushing the car, from left to right, are Joel Sebastian, Kris Erik Stevens, Larry Lujack, and Fred Winston. Behind the wheel is Chuck Buell.

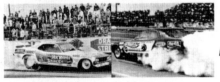

Gary Gears joined the Big 89 in 1971. With his big booming voice, Gears also had a successful voice-over career. He was the voice of Sears Auto Centers and the "Ho Ho Ho" in Green Giant commercials. He did voice work for many other television and radio stations. WLS used Gears as a station voice in the early 1980s. One of his more recognizable lines from that era was "Fewer commercials mean more music—on WLS!"

Steve Lundy, whose real name was Jack Foshee, had a style very similar to Dick Biondi, who occupied the same time slot 10 years earlier—big, bold, and loud. His trademark phrase, "Come together America! You're with Stevie in the nighttime," was heard during his time at WLS and other radio stations across the country.

Two Bill Baileys worked at WLS. The first joined the station from WKLO Radio in Louisville, Kentucky, to become morning man in 1969. However, he only stayed on for six months. The Bill Bailey pictured here came to WLS in 1971 and pulled the 9:00 p.m. to 1:00 a.m. shift for two years. He was also nominated for Air Personality of the Year by Billboard Magazine.

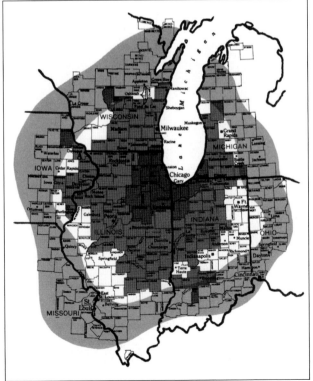

The WLS footprint is huge, as illustrated on this 1972 coverage map. The signal can be heard in seven states during the day and at night routinely reaches 38 states. Signal reports have been confirmed in all 50 states. Some hosts have claimed listeners from as far away as South America and Sweden have heard the 50,000-watt signal on 890 kHz. Until 1981, WLS was the only station that broadcast on this frequency.

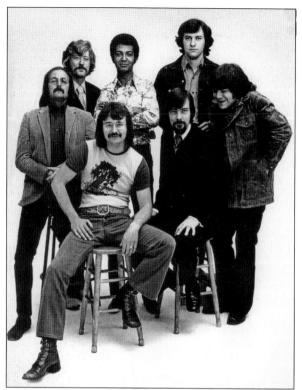

Here is a publicity photograph of the WLS air staff in 1973. From left to right are (first row) Chuck Knapp, Charlie Van Dyke, and Fred Winston; (second row) J. J. Jeffrey, Dick Sainte, Bill Bailey, and John Records Landecker. (Courtesy of Mark Romness.)

Dick Orkin, who brought fame to the *Chickenman* radio serial, attempted to do the same with *The Tooth Fairy*, which aired on WLS in the early 1970s. He and his "Radio Ranch" company can be heard on local commercials, including Empire Carpet and First American Bank, as well as national spots. Orkin (also known as Newton Snickers the Tooth Fairy) appears with his assistant Nurse Durkin and the Toothmobile.

Yvonne Daniels prepares to start the next song while on the air, shortly after joining WLS in 1973. She picked up the title "the Queen of Rock." Prior to the Big 89, Daniels played jazz music on Chicago stations WYNR, WCFL, and WSDM, where her show was known as *Daniels Den*. Daniels was a pioneer, as she was the first female disc jockey at WLS and the first to work full time on AM radio in Chicago. Her father was famous jazz musician Billy Daniels. She had said she always hated working the overnight shift but loved the listeners who checked in from all over the world, thanks to WLS's far-reaching signal. "I hate working all-night with a purple passion! [but] I feel very personally involved with my audience, like I'm sending a message to each one of them." She stayed with WLS until 1982. Daniels died of breast cancer in 1991 and now has an honorary street named after her in downtown Chicago. Daniels was inducted into the Radio Hall of Fame in 1995. (Courtesy of the Chicago Sun-Times.)

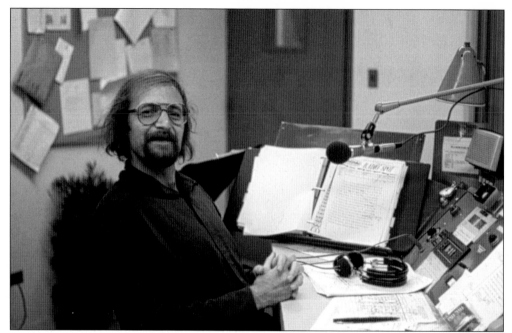

J. J. Jeffrey is taking a break during his midday show in 1974. His often light-hearted approach made him a listener favorite and sometimes the subject of good-natured pranks by his fellow employees. John Records Landecker has noted that "J," as he was known, was the inspiration for his *Boogie Check* program. (Courtesy of John Gehron.)

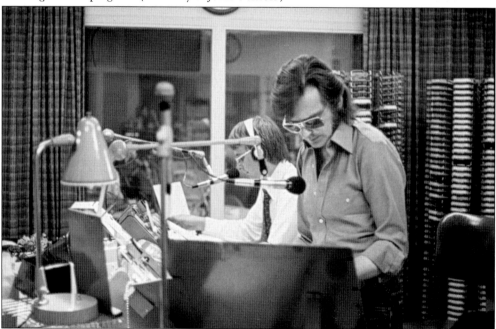

Steve King prepares for the start of his 10:00 p.m. to 2:00 a.m. show, while Jack Swanson (back left) airs the latest news report. King was one of several local on-air personalities that program director Tommy Edwards hired away from competing Chicago FM stations. He was one of the WLS personalities who successfully segued into a talk radio host. (Courtesy of John Gehron.)

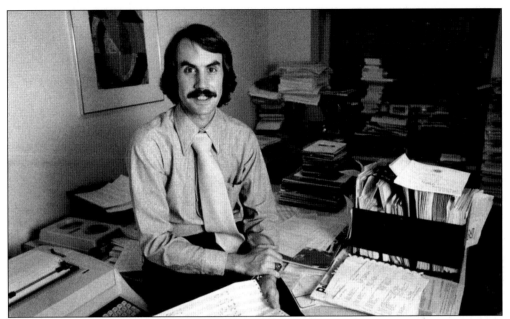

John Gehron, who came to WLS from WCBS in New York, is considered one of the most successful programmers of the rock era. He was responsible for helping WLS beat its rival WCFL and forcing them to change formats in 1975. Gehron also held the titles of operations manager and general manager during his 14-year run at WLS. He is pictured in his office in 1976. (Courtesy of the Chicago Sun-Times.)

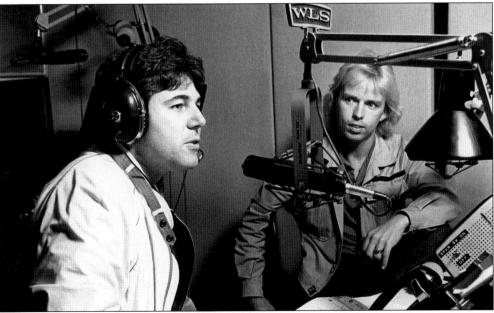

Styx lead singer Tommy Shaw chats with Jeff Davis (left). WLS essentially launched Styx's career into superstardom when Davis heard the song "Lady" being played over and over on a jukebox in a Chicago pizza parlor. WLS began playing the song in 1974. It became the group's first national hit shortly thereafter and earned Styx a record contract with A&M. (Courtesy of Jon Randolph and Jeff Davis.)

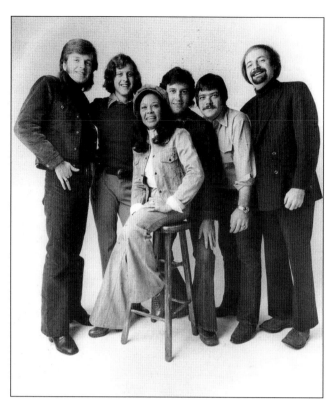

Pictured here are the WLS on-air personalities in 1975. From left to right are Steve King (late nights), Bob Sirott (afternoons), Yvonne Daniels (overnights), John Records Landecker (evenings), Fred Winston (mornings), and J. J. Jeffrey (middays). (Courtesy of John Gehron.)

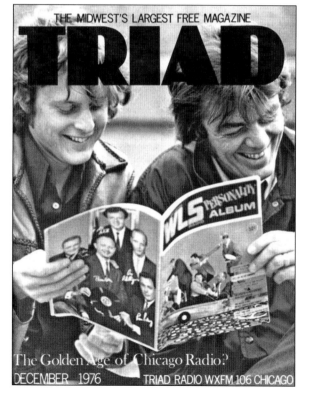

This is the cover of the December 1976 edition *Triad Magazine*, which was published by "underground radio" station WXFM. Bob Sirott and Larry Lujack "share a laugh" looking through the 1967 *WLS Personality Album*. Another shot from this photo session is featured on the cover of this book.

Bill Price was production director from 1975 to 1978. In addition to his behind-the-scenes duties, Price was also heard on the Musicradio Game promos. Along with Tommy Edwards, they called many listeners and asked them "what's your favorite radio station?" Price also hosted weekend shifts. Here he is seen in the batters box as a member of the WLS 89'ers softball team. Art Wallis followed Price as production director and station voice.

WLS was always known for big promotions and giveaways. Concert tickets, trips, sailboats, Disney World vacation packages, electronics, records, and T-shirts were among the thousands of things given away. In this 1978 promotion, WLS gave away a new Ford vehicle every day for 44 days. It was the biggest promotion up to that time. Two years later WLS gave away a brand-new $75,000 home as well as 30 Datsuns at a promotion at Comiskey Park.

John Records Landecker and friends get together for a picture to promote the first annual WLS 8.9 Mile Run for the Zoo. Edward the Chimp keeps a watchful eye on the hare and tortoise. (Courtesy of the Chicago Sun-Times.)

The Chicago skyline provides the backdrop for the first annual WLS 8.9 Mile Run for the Zoo, held along the lakefront to benefit the Lincoln Park Zoo.

Bob Sirott broadcasts from the window of I Magnin store on Michigan Avenue. He did an entire Saturday afternoon show in a mummy case while wrapped in gauze to commemorate the King Tut exhibit coming to Chicago. (Courtesy of John Gehron and Linda Waldman.)

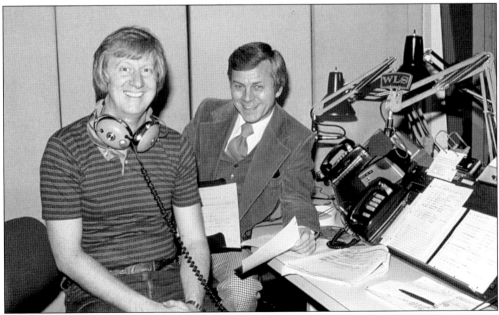

Midday host Tommy Edwards (left) is seen with former WLS personality Bob Hale in the late 1970s. During his 13½ years at the station, Edwards served as program director and production director and pioneered many promotions such as the Musicradio Game and also reintroduced the Musicradio survey sheets. He took over the 10:00 a.m. to 2:00 p.m. on-air shift in 1976 and remained there until moving to afternoons in 1982. (Courtesy of John Gehron.)

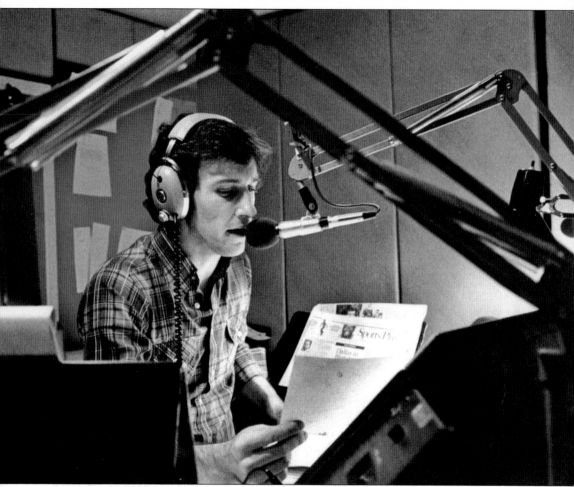

John Records Landecker's evening show in the 1970s was a must-listen. He answered telephone calls with lightning speed during the *Boogie Check* and had a unique sense of how to entertain teenagers and adults alike. Other features included *Americana Panarama*, a winding story that would end in a song title. His parody of Lou Reed's "Walk On The Wild Side" called "Make a Date with the Watergate" was released as a promotional Flexi-Disc, along with the comedy bit "Press My Conference," which featured fellow WLS voices and musical snippets, reminiscent of the Dickey Goodman novelty records of the 1960s and 1970s. He recorded "Jane (Beat the Machine Dame)," about Jane Byrne's election as mayor of Chicago, with Jefferson Starship. "Cabrini Deeds," a remake of the AC/DC classic "Dirty Deeds," was recorded with local group the Kind and performed live at Great America. As Landecker would say, "Records truly is my middle name." He is correct, as his middle name was his mother's maiden name. (Courtesy of the Chicago Sun-Times.)

Despite being a music outlet, WLS had a news staff that rivaled the news and talk stations of the day. They worked around the clock and hit the streets for stories. This picture, taken in October 1978, features from left to right news director Bud Miller, Catherine Johns, Jeffrey Hendrix, Jim Johnson, writer Ira Johnson, Linda Marshall, Harley Carnes, Karen Hand, producer Lon Dyson, and Bob Conway in the clock above the news booth door. (Courtesy of Karen Hand and Catherine Johns.)

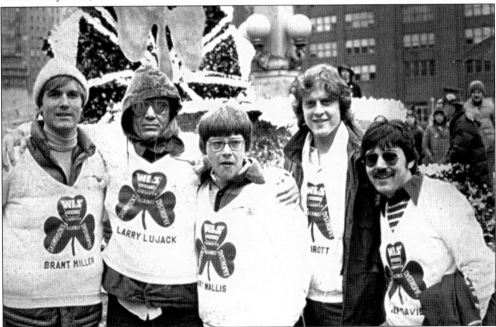

Chicago is still a cold place on St. Patrick's Day. The air staff convenes for a quick picture after riding down State Street on the WLS float in 1979. Pictured are Brant Miller, Larry Lujack, WLS production director and station voice Art Wallis, Bob Sirott, and Jeff Davis. (Courtesy of John Gehron.)

Jock of the Week

?

THE BEST MUSIC
IN CHICAGO
6PM — 10PM

MUSICRADIO 89

Thirty-threes

1	1	Cornerstone	Styx
2	2	The Long Run	Eagles
3	3	In Through The Out Door	Led Zeppelin
4	4	Greatest Hits—On The Radio	Donna Summer
5	5	Wet	Barbra Streisand
9	6	The Wall	Pink Floyd
6	7	Evolution	Journey
7	8	Kenny	Kenny Rogers
13	9	Damn The Torpedoes	Tom Petty & The Heartbreakers
8	10	Tusk	Fleetwood Mac
11	11	Breakfast In America	Supertramp
10	12	Dream Police	Cheap Trick
16	13	Greatest Hits	Bee Gees
15	14	Rise	Herb Alpert
12	15	Midnight Magic	Commodores
14	16	Off The Wall	Michael Jackson
22	17	Freedom At Point Zero	Jefferson Starship
17	18	Night In The Ruts	Aerosmith
18	19	Head Games	Foreigner
19	20	One Voice	Barry Manilow
23	21	Live Rust	Neil Young & Crazy Horse
26	22	The Gambler	Kenny Rogers
20	23	Highway To Hell	AC/DC
21	24	Flirtin' With Disaster	Molly Hatchet
24	25	Candy-O	The Cars
25	26	Journey Through The Secret Life Of Plants	S. Wonder
27	27	Get The Knack	The Knack
33	28	Greatest Hits	Electric Light Orchestra
28	29	The Cars	The Cars
xx	30	Phoenix	Dan Fogelberg
29	31	Love Drive	Scorpions
32	32	Van Halen II	Van Halen
31	33	Million Mile Reflections	Charlie Daniels Band

WLS plays selected music from these lists.

Concerts in the Weeks Ahead

Aerosmith — Amphitheatre — December 26
Charlie Daniels Band — Uptown — December 27
R. E. O. Speedwagon — Amphitheatre — December 29

Forty-fives

LW	TW	WEEK ENDING DEC. 29, 1979	VOL. 20, NO. 11
1	1	Babe (6th Week No. 1)	Styx
4	2	Escape (The Pina Colada Song)	Rupert Holmes
2	3	No More Tears (Enough Is Enough)	Streisand/Summer
3	4	Pop Muzik	M
7	5	Please Don't Go	KC & The Sunshine Band
6	6	Still	Commodores
5	7	Lovin', Touchin', Squeezin'	Journey
9	8	Heartache Tonight	Eagles
8	9	Ladies Night	Kool & The Gang
12	10	Take The Long Way Home	Supertramp
10	11	Rise	Herb Alpert
15	12	You're Only Lonely	J. D. Souther
24	13	Jane	Jefferson Starship
11	14	Dream Police	Cheap Trick
13	15	Tusk	Fleetwood Mac
26	16	Coward Of The County	Kenny Rogers
25	17	We Don't Talk Anymore	Cliff Richard
20	18	Don't Let Go	Isaac Hayes
22	19	Head Games	Foreigner
14	20	Ships	Barry Manilow
28	21	Send One Your Love	Stevie Wonder
29	22	Half The Way	Crystal Gayle
35	23	The Long Run	Eagles
32	24	Do That To Me One More Time	Captain & Tennille
17	25	Rappers Delight	Sugarhill Gang
16	26	Good Girls Don't	The Knack
27	27	Dreaming	Blondie
21	28	You Decorated My Life	Kenny Rogers
18	19	Don't Stop 'Til You Get Enough	Michael Jackson
19	30	Dim All The Lights	Donna Summer
23	31	Sad Eyes	Robert John
43	32	Don't Do Me Like That	Tom Petty & The Heartbreakers
31	33	Broken Hearted Me	Anne Murray
30	34	Come To Me	France Joli
33	35	Sail On	Commodores
36	36	My Sharona	The Knack
45	37	Cool Change	Little River Band
xx	38	Rock With You	Michael Jackson
34	39	Bad Case Of Loving You	Robert Palmer
38	40	Don't Bring Me Down	Electric Light Orchestra
37	41	Lonesome Loser	Little River Band
xx	42	Why Me?	Styx
40	43	The Devil Went Down To Georgia	Charlie Daniels Band
41	44	Do You Think I'm Disco?	Teenage Radiation
xx	45	Deja Vu	Dionne Warwick

In December 1979, John Records Landecker moved from nights to afternoons to fill Bob Sirott's time slot. Sirrot had left WLS to pursue other interests, mainly television. While the search for a nighttime replacement was going on, this survey gave no clue as to who it would be. It was one of the very few times that a survey did not have a picture of a WLS jock on it.

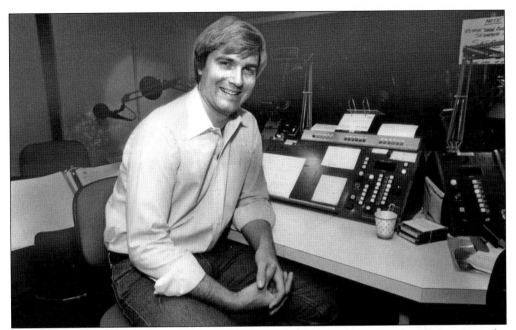

Brant Miller, who had been working the past two years as a part-time host, was given the evening shift permanently. In December 1980, his nightly show was heard on both WLS AM and WRCK-FM 95, which quickly became WLS-FM. By 1985 Miller was moved to afternoons solely on WLS-FM, which became WYTZ "Z-95." (Courtesy of the Chicago Sun-Times.)

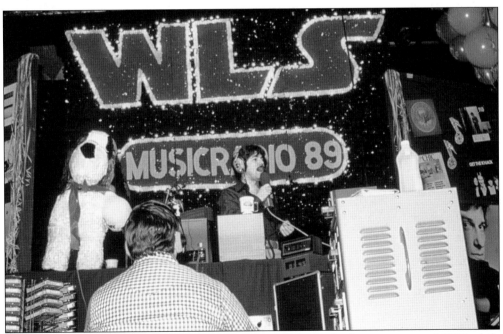

Jeff Davis and Brant Miller (not pictured) counted down the biggest songs of 1979 while broadcasting live from Old Chicago Amusement Park and Mall in Bolingbrook, Illinois. The New Years Eve Big 89 Countdown would be the last big party as the complex would shut its doors just three months later, due to financial difficulties. (Courtesy of John Gehron.)

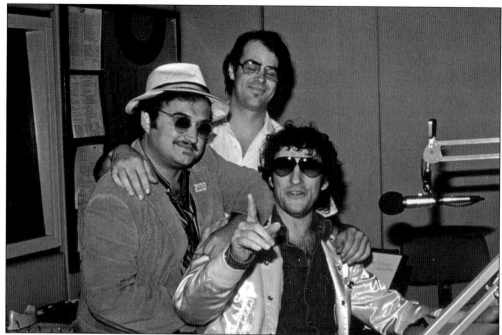

John Belushi and Dan Aykroyd stopped by to chat with John Records Landecker (right) during the filming of *The Blues Brothers* movie in 1979. (Courtesy of John Gehron.)

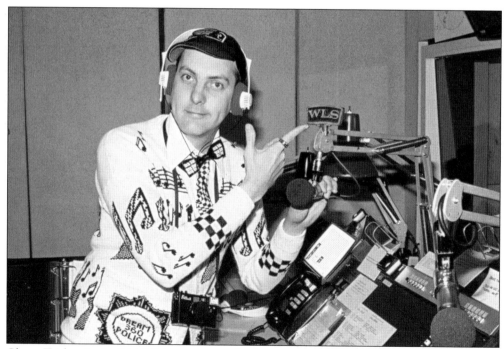

Cheap Trick guitarist Rick Nielsen points to his favorite when he got to be a guest disc jockey in early 1980. WLS considered Cheap Trick a local band since they hailed from Rockford, Illinois. (Courtesy of John Gehron.)

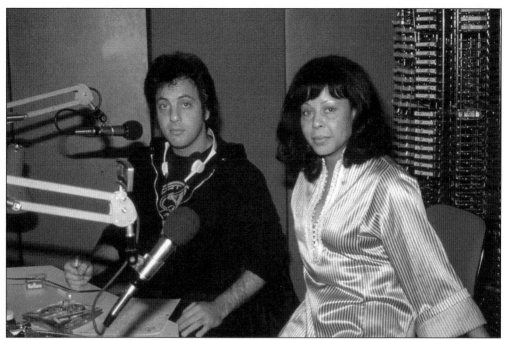

Billy Joel and Yvonne Daniels pose for a picture in Studio A in the early 1980s. Many musical acts not only dropped by WLS but appeared on the Sunday night music and interview show *Musicpeople*. (Courtesy of John Gehron.)

Sports director Les Grobstein signs autographs before the Chicago Radio All Stars played softball against the faculty of Gemini Junior High School in Niles in 1983. The Chicago Radio All Stars were team members from various local stations that were known in the 1980s for their charity softball and basketball games. (Courtesy of Les Grobstein.)

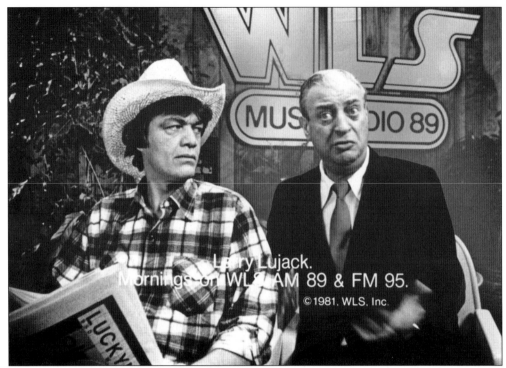

These photographs were taken during the filming of a WLS television commercial featuring Larry Lujack and comedian Rodney Dangerfield in 1982. The commercial ran on quite a few Chicago television stations, and the run was extended several times. The top picture is a promotional still from the commercial. Below, the set was an exact replica of the WLS reception area. (Below, courtesy of Robert Feder.)

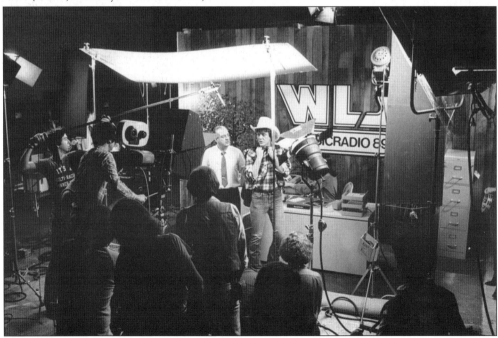

Steve Dahl and Garry Meier (left) spent five tumultuous years at WLS after being fired from WLUP for reportedly "violating community standards." They started in 1981, doing afternoons at WLS-FM, but were eventually moved to WLS-AM against their wishes in 1984. After seemingly endless weeks of no-shows, name calling, legal litigation, and numerous suspensions, the two returned to finish out their contract. (Courtesy of the Chicago Sun-Times.)

Steve Dahl and his band Teenage Radiation continued to rock during the WLS years. They appeared in concert and recorded several songs like "I'm a Wimp," "Nobody's Perfect," and "Falklands." They released the 45 rpm single "RTA" in 1981, a parody based on the AC/DC song "T.N.T." and the album *Pet Fishsticks* in 1983.

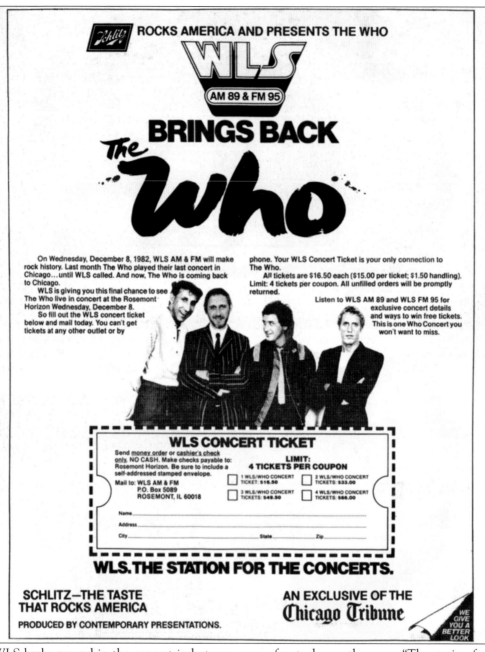

WLS broke ground in the concert industry on many fronts, hence the name "The station for the concerts." In the 1970s, the station broadcast live shows by Styx and Fleetwood Mac. It was instrumental in presenting the Rolling Stones "Tattoo You" show in 1981 as well as the Police at Comiskey Park in 1983. A 1982 concert by the group Chicago to benefit the Terry Kath Foundation at the Park West was the first live concert to be broadcast in AM stereo. However, the biggest coup was bringing the Who back to Chicago for their final "farewell tour" show (the second time they played here on the tour) in December 1982. Since WLS brought the Who back, the station sold all the tickets themselves. WLS also reunited the original members of the Buckinghams for a show at ChicagoFest in 1980.

Chris Shebel took over the midday show in 1982 when Tommy Edwards moved to afternoons. He was later shifted over to the same time slot on WLS-FM, where he is pictured here in 1983. His very first day on the air included a "hardball" on-air interview by "Mr. Lujack" before his show started. Quite an initiation indeed! (Courtesy of John Gehron.)

Tom Graye worked several shifts on both WLS-AM and WLS-FM, as well as their former identities as WRCK-FM "W-Rock" and WDAI. He also worked in the production department as well as a stint as assistant program director before moving on to program a pair of stations in Rockford, Illinois.

The unforgettable jingles that WLS aired came primarily from two companies. From the 1960s through the mid-1970s, PAMS created the musical breaks between the records. From the late 1970s all the way to today, JAM Creative Productions of Dallas has been responsible for the WLS jingles. This 1986 photograph shows the JAM singers. They are, from left to right, Jim Clancy, Brian Beck, Chris Kershaw, Greg Clancy, and Judy Parma. (Courtesy of John Gehron.)

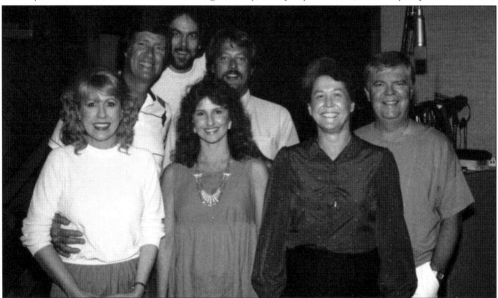

Here is the seven-voice JAM vocal group in 1985. They are, from left to right, Judy Parma (second girl), Jim Clancy (bass), Bruce Upchurch (second tenor), Kay Sharpe (third girl), Chris Kershaw (lead tenor), Jackie Dickson (lead girl), and Dan Alexander (baritone). JAM president Jonathan Wolfert noted that "There are many other singers and writers who have been part of WLS jingles through the years, but this photo represents a pretty good cross-section." (Courtesy of Jonathan Wolfert.)

The popular *Animal Stories* feature was an outgrowth of Larry Lujack reading farm reports in the early 1970s. As time went on, the stories got zanier and Lujack asked Tommy Edwards to join him. Their chemistry together made the feature laugh-out-loud funny and an instant hit. Listeners would submit stories that they found, vying for an opportunity to be a "bureau chief." Uncle Lar and Lil' Snot-nosed Tommy released three best-of albums, which 100 percent of the profits were donated to the Forgotten Childrens Fund. Over a $250,000 was donated to the charity from album sales. Above is the first *Animal Stories* album from 1981. Edwards and Lujack are pictured below at a WLS 89'ers basketball game. (Below, courtesy of John Gehron.)

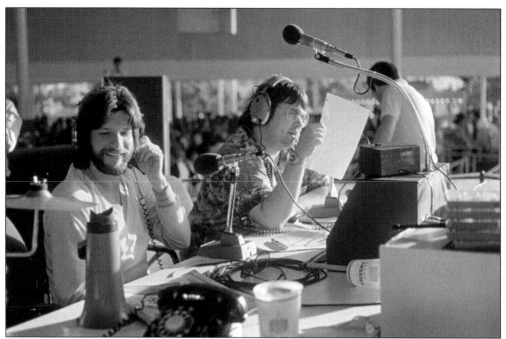

Above, Steve Dahl and Garry Meier are seen broadcasting on WLS-FM from the grand opening of the American Eagle rollercoaster, located in the Eagle Tent at Mariott's Great America in 1981. John Records Landecker was on hand for live broadcasts during the opening of the Tidal Wave coaster in 1978. He was the first to ride the coaster, which featured a commemorative plaque of the event. Over the years, WLS spent many hours broadcasting from the park. Below, station engineer Ed Glab is surrounded by radio equipment, tape cartridges, and spectators during one of the many remotes in the park's Hometown Square gazebo. (Courtesy of John Gehron.)

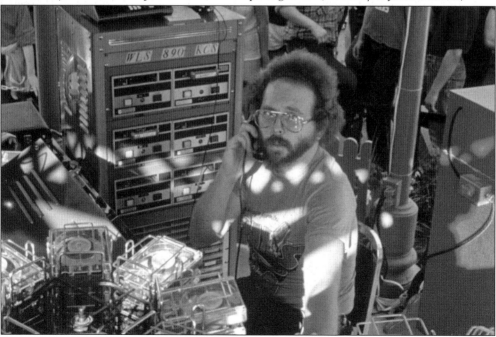

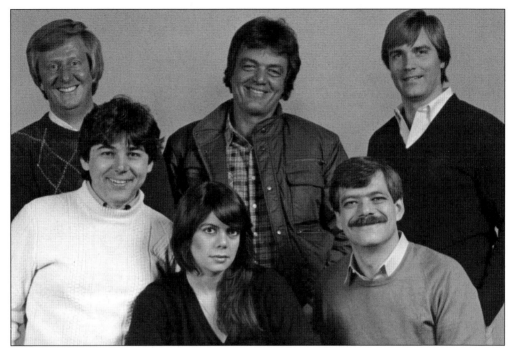

The WLS-AM 89 staff in 1983 is, from left to right, (first row) Jeff Davis (late nights), Turi Ryder (overnights), and Fred Winston (middays); (second row) Tommy Edwards (afternoons), Larry Lujack (mornings), and Brant Miller (evenings).

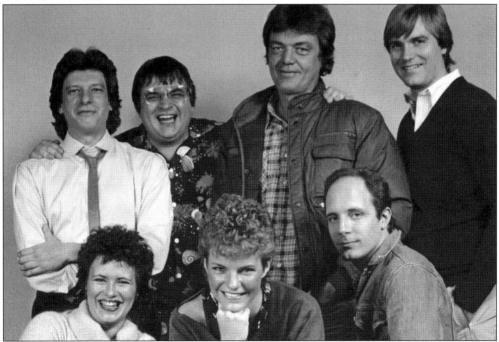

The WLS-FM 94.7 staff is seen here in 1983. From left to right are (first row) Susan Platt (middays), Amy Scott (overnights), and Chuck Evans (late nights); (second row) Steve Dahl and Garry Meier (afternoons), Larry Lujack (mornings), and Brant Miller (evenings).

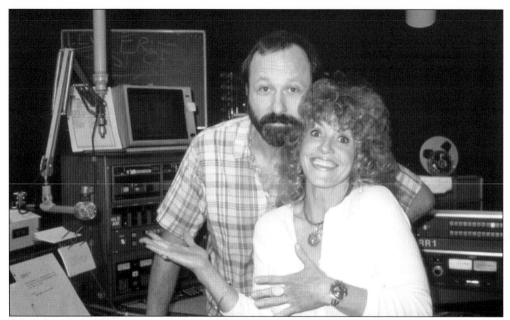

Don Wade joined WLS as the midday host in 1985. Roma Wade, who was featured on his show, became a permanent fixture a year later. Don had previously hosted at US-99 FM. In the early days, it was not divulged that Don and Roma were married, although many figured it out on their own. As the 1980s came to an end, their show featured less music and more talk. They were promoted to mornings when WLS flipped to a talk format. (Courtesy of John Gehron.)

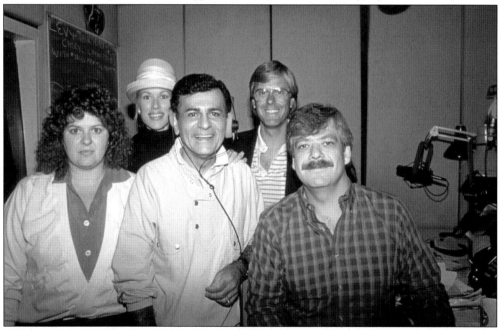

Countdown king Casey Kasem visits the WLS offices in 1986. His show *American Top 40* began airing on WLS in 1982. Here he is pictured with the *Fred Winston Morning Show*. From left to right are Catherine Johns, Casey's wife and actress Jean Kasem, Casey Kasem, Jim Johnson, and Fred Winston.

Chuck Britton held many different airshifts during his time at WLS AM and FM in the 1980s. Seen above, he is in-studio at WLS-AM. Below, he is broadcasting his popular *Saturday Night Oldies Show* from Ed Debevic's restaurant in downtown Chicago in 1986. He remarked that "music artists and local celebrities were always stopping by. I also had hot rod clubs from all over Illinois and Indiana drive to Ed's when the weather was nice just to have their cars on display for the atmosphere. I have a lot of great memories." Britton is pictured with his producer Wayne (left) in the radio booth.

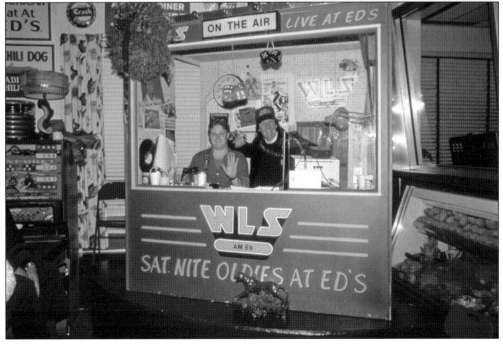

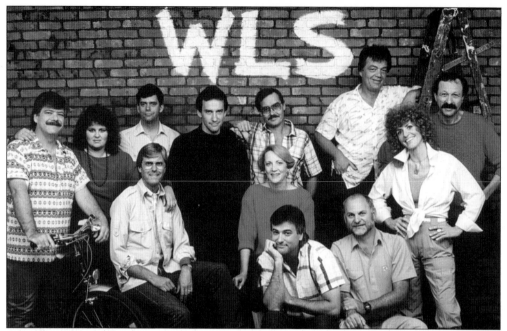

The WLS on the air staff in 1986 is pictured here. From left to right are (first row) are Jim Johnson, sex therapist call-in talk host Phyllis Levy, Rich McMillian, Jeffrey Hendrix, and Roma Wade; (second row) Fred Winston, Catherine Johns, Les Grobstein, John Records Landecker, traffic reporter and weekend personality Don Nelson, Larry Lujack, and Don Wade.

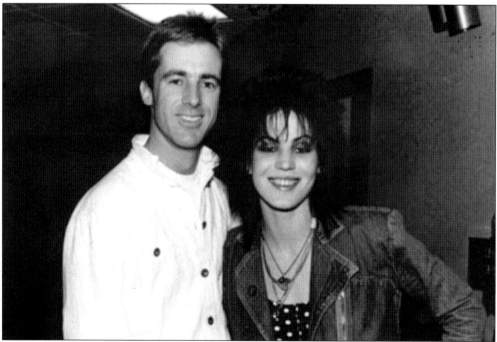

Ric Lippincott is pictured with rocker Joan Jett. Lippincott managed at WLS twice, first as program director in 1981–1982 and then again as operations director of WLS and WYTZ-FM (WLS's sister station) beginning in 1986. (Courtesy of Ric Lippincott.)

Chuck Crane was WLS music director and on the air as "Doctor" Chuck Crane in 1986. It was not just a zany radio name, as Crane was actually a dentist! He continues his practice in Florida. (Courtesy of John Gehron.)

Over the years WLS presented many concerts. The group Chicago (pictured) and the Buckinghams appeared at the Taste of Chicago, held in Grant Park in 1987. The show was broadcast live on the station. It was one of the final shows the station presented as a music station. (Courtesy of John Gehron.)

Larry Lujack listens to a caller on his last day at WLS on August 28, 1987. Lujack moved to the afternoon drive shift a year earlier after nearly 10 years working mornings at WLS. In his final moments, he thanked the listeners "not just for listening, but also for caring." (Courtesy of the Chicago Sun-Times.)

Rich McMillan began his career at ABC Chicago as production director and on-air talent at WRCK, which became WLS-FM in December 1980. He eventually moved over to the AM side and was one of the first jocks to host the *Saturday Night Oldies Show* from Ed Debevic's restaurant on WLS. In 1986, McMillan was teamed up with Larry Lujack when he moved to afternoons. He currently manages several stations in Miami, Florida.

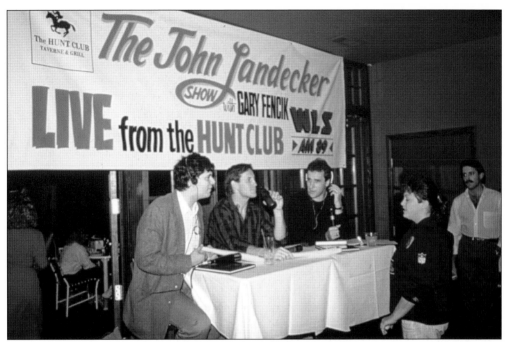

In late 1986, John Records Landecker's show transitioned from music to more talk. Pictured from left to right are sports director Les Grobstein, former Chicago Bear Gary Fencik, and Landecker during a live broadcast at Fencik's restaurant, the Hunt Club in Chicago. (Courtesy of John Gehron.)

Phil Duncan was the last music jock heard on WLS. On Wednesday, August 23, 1989, at 7:00 p.m., the music came to an end after over 29 years. He had been filling in on the afternoon shift when the word suddenly came down. "It was in those last couple of minutes that we realized we would be playing the last song as we headed up to news time. So I just sort of looked through a few songs and decided "Just You and Me" by Chicago was about as good as I could come up. We didn't have time to plan a goodbye. It surprised us." (Courtesy of Phil Duncan.)

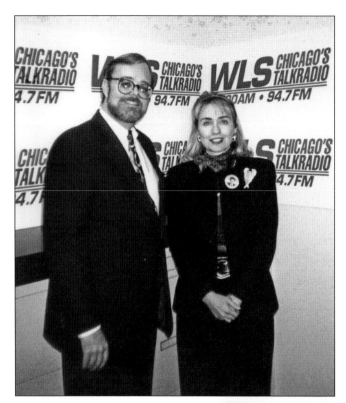

Tom Tradup was the first vice president and general manager of WLS after the switch to talk radio. Here he poses with Hillary Rodham Clinton, prior to her husband Bill winning the White House. In this picture from March 1992, Hillary stopped by the radio station while on the campaign trail for her husband.

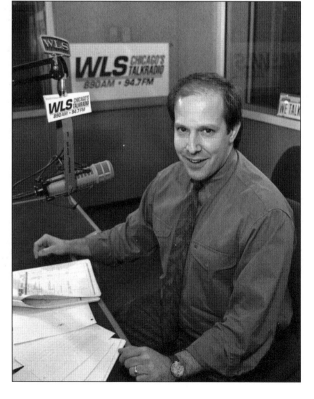

Drew Hayes debuted in Chicago as a talk-show host on WMAQ-AM in the mid-1980s. When WLS flipped to talk in 1989, Hayes was hired as operations manager and is credited with turning the station around. During his tenure, he brought in Jay Marvin, debuted the "WLS-FM Talks" format, and paired Roe Conn with Garry Meier. Hayes also hosted a weekend talk show.

Five

NEWS-TALK 890

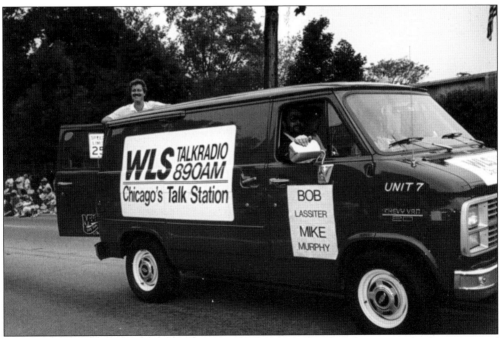

With the erosion of music listeners to the FM band, WLS needed to adapt to the times and the format switch to talk was made. What would make them stand out? Early on it was an issue-oriented, in-your-face confrontational presentation known as *Hot Talk*. WLS had slipped so far in the ratings, it needed to make some noise. Pictured above are Mike Murphy (on the bumper), host of the sports show *Fan Talk*, and afternoon host Bob Lassiter riding down LaGrange Road in the WLS van during the annual LaGrange Pet Parade in 1990.

Bob Lassiter was one of the first *Hot Talk* hosts hired after the format switch. Known as "Mad Dog," he was a controversial firebrand, brought in from Tampa, Florida, to make listeners stand up and take notice of the new WLS. And take notice they did, as he would routinely berate callers and guests who did not agree with him. After many tussles with management, Lassiter returned to Tampa after only two and a half years at Talkradio 890.

Wayne Messmer has been a popular singer and public address announcer for the Chicago Cubs and Chicago Wolves for many years. In 1986, he joined WLS's sister station WYTZ-FM (Z-95) as a morning news anchor. By 1990, Messmer transitioned to WLS-AM, where he was midday news anchor. Tragedy struck in 1994 when he was mugged and shot in the throat in front of a West Side restaurant. He survived the incident and endured months of physical therapy. Miraculously, he was able to continue his career as a singer and announcer. (Courtesy of Michael Garay.)

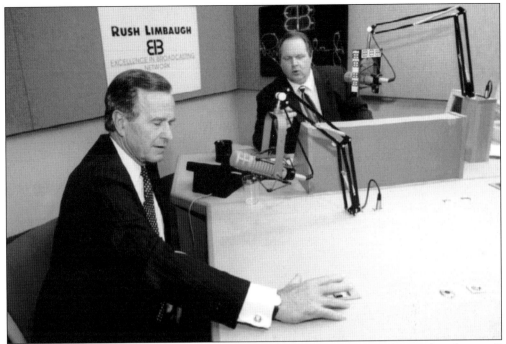

Rush Limbaugh has been widely recognized as "the savior of the AM band." His show has aired on WLS ever since its debut as a talk station. Here Limbaugh interviews Pres. George H. W. Bush in September 1992. (Courtesy of Eric Rhoads and Radio Ink.)

Don Wade led the charge for lower gas prices during a remote broadcast at a service station at Roosevelt Road and Seventeenth Avenue in Broadview, Illinois, in the early 1990s. The event made headlines as cars were lined up for blocks to buy gasoline. Don and Roma joined WLS during the music era but stayed on after the format change. Since then they have gone on to become the longest-running morning show in Chicago.

While many across the country know Richard Roeper as a newspaper columnist and cohost of the television series *At the Movies with Ebert & Roeper*, he also spent time as a daily talk-show host at WLS-FM, during the "FM Talks" format in 1994 and 1995.

Catherine Johns made the transition from news anchor to talk host in 1990 after working for over 10 years as a part of Larry Lujack and Fred Winston's morning shows. She enjoyed being able to call the shots. "I enjoy interviewing, and while I'd done a lot of that as a newsperson, having a guest on a talk show allowed for much more in-depth conversation."

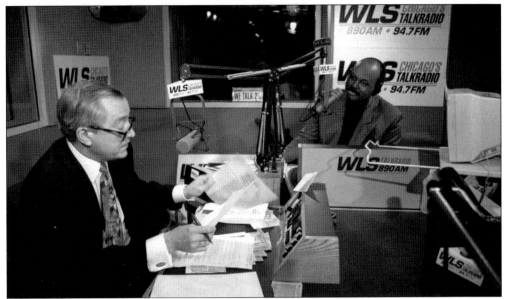

It was a match that could be made only in Chicago. In 1993, WLS made headlines when it paired former Chicago alderman Ed Vrdolyak (left) with veteran Chicago newsman Ty Wansley. The pair often disagreed on topics, coming from different political backgrounds. This, along with polarized callers, sometimes lead to heated exchanges. The show fell apart after Vrdolyak reportedly clashed with management. The pair regrouped as the morning team at WJJD in 1995.

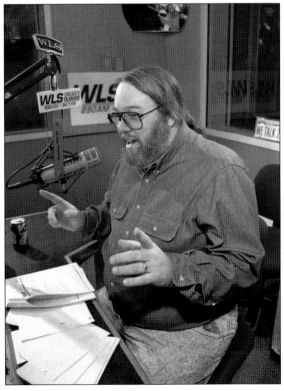

Jay Marvin brought his irreverent style of talk to WLS in 1993. A former country disc jockey, he melded the high-intensity patter with talk radio and gained an instant following known as "the Nation of Marvin." His popularity only grew after he left and then returned in 1999 to host evenings and then middays with Eileen Byrne. Marvin, who is also a poet, artist, and writer with published works, left for Denver in 2005.

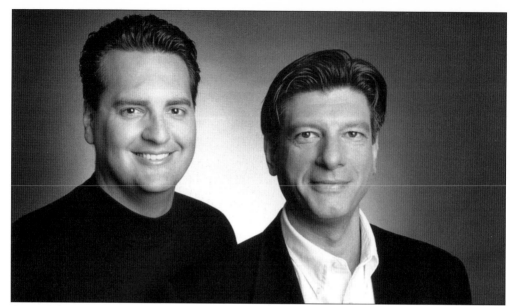

One of the most popular shows on WLS came together almost by accident. After a chance meeting with Drew Hayes, Garry Meier auditioned with Roe Conn as a duo. The shows went so well, the pair did a one-week trial, which eventually led to the two working together permanently. *Roe & Garry* consistently led afternoon ratings from 1996 to 2004, when Meier decided not to renew his contract. Roe Conn continues on as afternoon host, along with Bill Leff and newsman Jim Johnson.

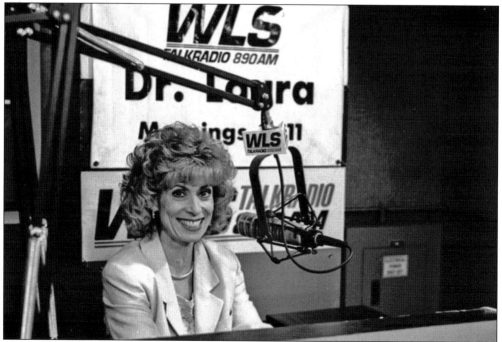

In 1996, Dr. Laura Schessinger's syndicated advice call-in show was added to the weekday morning lineup as a lead-in to Rush Limbaugh. It aired for six years on the station. She is pictured on a trip to Chicago in the WLS studios.

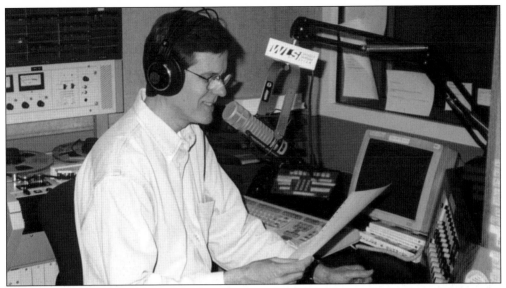

Jim Johnson, pictured in the WLS newsroom, has the unique distinction of being the longest-tenured on-air staff member at WLS. He signed on as a reporter in 1968. He has covered the riots of the 1960s, the council wars of the 1970s, and both of Chicago's Democratic National Conventions in 1968 and 1996. Johnson was the first radio reporter on the scene when a DC-10 lost its engine shortly after takeoff and crashed near O'Hare in 1979. His coverage and reporting on the Fox River Grove school bus–train collision earned him a coveted 1995 Edward R. Murrow Award.

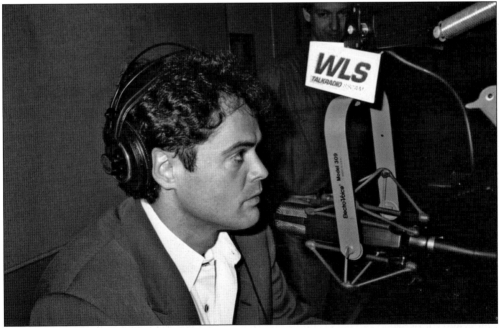

Even though WLS took talk very seriously in the early years, tackling the top news and political stories, there was still time to cover the fun stuff. Donny Osmond, whose music was played on the station during the Musicradio years, stops by to talk about his lead role in the Chicago production of *Joseph and the Amazing Technicolor Dreamcoat*. (Courtesy of Michael Garay.)

Here is the WLS on-air staff in 1999. From left to right are Don Wade, Jay Marvin, Garry Meier, Roma Wade, Roe Conn, Catherine Johns, and a "one-dimensional" Rush Limbaugh. (Courtesy of Michael Garay.)

From 1997 to 2006, Steve Scott doubled as WLS's news director and morning news anchor. He took on reporting assignments from Bosnia and Albania, spent a week at Ground Zero in New York shortly after the attacks, and met and interviewed Fidel Castro in Cuba. Many of his reports also aired on the ABC Radio Network. Off the air, Scott was the public address announcer for the Chicago Bulls, a job that has also been held by fellow WLS alum Tommy Edwards. (Courtesy of Steve Scott.)

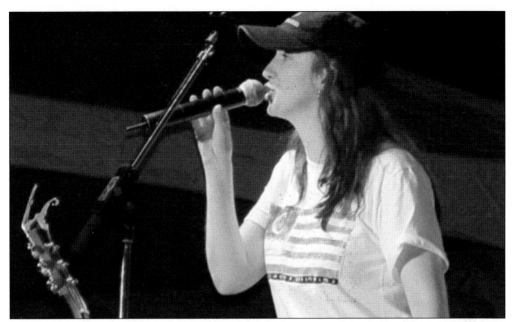

Eileen Byrne began hosting weekends and was later paired with Jay Marvin. Politically conservative, she had previously worked as a host and assistant program director at a talk station in Orlando, Florida. Byrne is very involved with helping charity organizations. Here she is pictured emceeing the 2006 benefit concert for Operation Support Our Troops at Catigny Park in Wheaton.

Morning news anchor Cisco Cotto is getting a haircut by stylist Mercedes. "Don and Roma asked me to shave my hair to look like Brazilian soccer star Ronaldo during the World Cup," Cotto commented. "Unfortunately for me I had a vacation planned to start the day after and I burned my scalp while on the beach!" (Courtesy of Cisco Cotto.)

Morning news anchor John Dempsey poses with WLS news director Jennifer Keiper. Both possess extensive news backgrounds including stints at all-news outlets WBBM and the former WMAQ. (Courtesy of Michael Garay.)

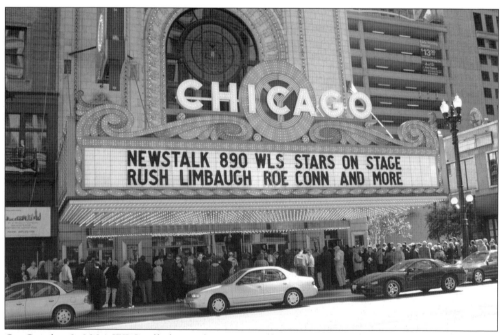

On October 2, 2004, WLS rolled out a big stage production, reminiscent of the *Barn Dance* days. However, it was talk, not music, that took top billing. The WLS *Stars On Stage* brought together the station's talent lineup for a daylong talkfest at the Chicago Theatre, starring Rush Limbaugh and many of the WLS talk hosts.

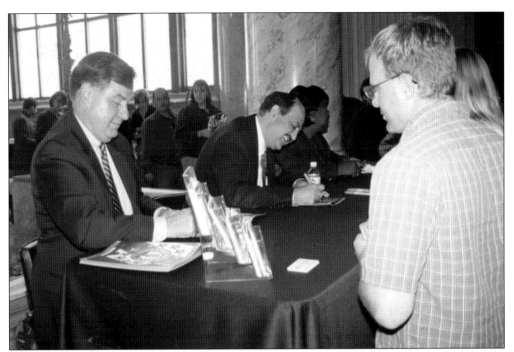

News and talk hosts Bill Cameron (left), George Noory, and Deborah Rowe talk with the audience and sign autographs in the theater lobby. Below, members of the *Roe Conn Show* toast the audience with the Canarble Wagon at center stage. The Canarble Wagon is a drink cart that is a regular feature on their show on Friday afternoons.

Posing for a photograph during the WLS *Big 89 Rewind* are, from left to right, Les Grobstein, wearing a vintage WLS baseball shirt; Tommy Edwards, who hosted the morning show with Larry Lujack on a broadcast hookup from his studio in Santa Fe, New Mexico; and Fred Winston.

Chris Shebel reprised his role as midday personality during the *Big 89 Rewind*. He joined WLS in 1982 from Columbus, Ohio, and later moved over to WLS-FM.

Six

THE BIG 89 REWIND

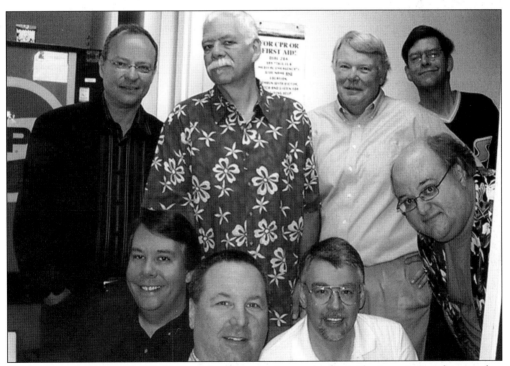

On Memorial Day 2007, WLS stopped talking and went back to playing music—for one day. The *Big 89 Rewind* brought back the disc jockeys and newspeople to re-create the sound of the 1970s and 1980s. The program also featured tributes to former hosts, such as Dick Biondi, Charlie VanDyke, and Yvonne Daniels. Above, the *Rewind* crew clockwise from left top includes air personalities Tom Kent and Fred Winston, former engineer Mark Romness, sportscaster Les Grobstein, WLS program director Kipper McGee, *Rewind* musicologist Bill Shannon, *Rewind* coordinator Jay Philpott, and lead historical consultant Scott Childers.

John Records Landecker checks in before the start of his segment. One of the most popular moments of the *Rewind* was the return of *Boogie Check*. This was the first time that Landecker reprised the famous listener call-in segment since 1980. Pictured from left to right are Landecker, former WLS music librarian and record turner Michaela Nelson (seated), Kipper McGee, and former WLS researcher Kurt Hanson. Hanson now heads up the *Radio and Internet Newsletter* and the multichannel Internet radio station known as AccuRadio.

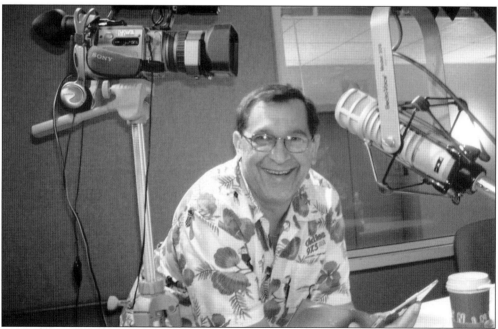

Filming all the festivities was Art Vuolo, who is known as "radio's best friend." Vuolo has spent his career recording and videotaping radio personalities from all across the country. He also is the author of the *Radioguide*, a fold-out directory of radio stations available in a number of major cities.

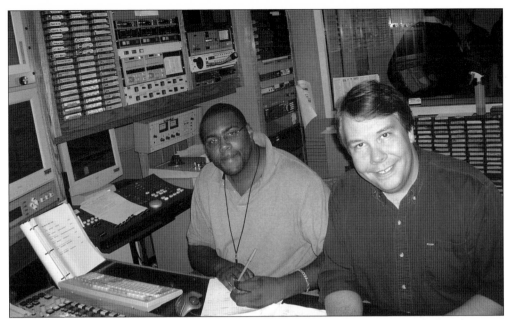

Pausing for a picture while operating the controls for the John Records Landecker show are Brian Althimer and Scott Childers. Althimer works as a technical producer at WLS. While Childers controlled the sound, played the music, and operated the microphones that went out over the air during the show, Althimer organized and logged the commercials and promotional announcements that were to be played on the air.

John Records Landecker, who at the time hosted afternoons at sister station True Oldies 94.7 FM, brought back many of his original benchmarks such as *Americana Panorama, Can I Get a Witness News*, and the popular *Boogie Check*.

ACROSS AMERICA, PEOPLE ARE DISCOVERING SOMETHING WONDERFUL. *THEIR HERITAGE.*

Arcadia Publishing is the leading local history publisher in the United States. With more than 3,000 titles in print and hundreds of new titles released every year, Arcadia has extensive specialized experience chronicling the history of communities and celebrating America's hidden stories, bringing to life the people, places, and events from the past. To discover the history of other communities across the nation, please visit:

www.arcadiapublishing.com

Customized search tools allow you to find regional history books about the town where you grew up, the cities where your friends and family live, the town where your parents met, or even that retirement spot you've been dreaming about.